My
iPhoto®

Michael Grothaus

My iPhoto®

Copyright © 2014 by Pearson Education, Inc.

ISBN-13: 978-0-7897-5011-2
ISBN-10: 0-7897-5011-2

Library of Congress Control Number: 2013957037

Printed in the United States of America

First Printing: March 2014

Trademarks

Warning and Disclaimer

Special Sales

For information about buying this title in bulk quantities, or for special sales opportunities (which may include electronic versions; custom cover designs; and content particular to your business, training goals, marketing focus, or branding interests), please contact our corporate sales department at corpsales@pearsoned.com or (800) 382-3419.

For government sales inquiries, please contact governmentsales@pearsoned.com.

For questions about sales outside the U.S., please contact international@pearsoned.com.

Editor-in-Chief
Greg Wiegand

Senior Acquisitions Editor
Laura Norman

Development Editor
Charlotte Kughen

Managing Editor
Kristy Hart

Senior Project Editor
Betsy Gratner

Copy Editor
Karen Annett

Senior Indexer
Cheryl Lenser

Proofreader
Dan Knott

Technical Editor
Greg Kettell

Editorial Assistant
Cindy Teeters

Cover Designer
Mark Shirar

Compositor
Mary Sudul

Contents at a Glance

Table of Contents

10 Editing Basics 155

13　Sharing Your Photos Digitally　　237

About the Author

Michael Grothaus is a journalist and author whose writing has appeared in *Fast Company*, *The Guardian*, *TUAW*, *Screen*, and more. Additionally he's a former screenwriter and the author of a dozen books on technology. Having worked for institutions such as 20th Century Fox, The Art Institute of Chicago, and Apple, he now lives in London and writes full-time. His writing is read by millions each month.

Dedication

This book is dedicated to Abbey, Ana, Bruna, Cris, Joana, Marta, Silvia, Soraia, Charlie, Duarte, Jose, Miguel, Paulo, Tiago, my mother, my brother, and everyone else who kindly let me use photos of them.

Acknowledgments

I'd like to thank my wonderful team of editors, reviewers, and copywriters at Que. I'd also like to thank everyone who put up with me being unavailable during the time I worked on this book.

We Want to Hear from You!

As the reader of this book, *you* are our most important critic and commentator. We value your opinion and want to know what we're doing right, what we could do better, what areas you'd like to see us publish in, and any other words of wisdom you're willing to pass our way.

We welcome your comments. You can email or write to let us know what you did or didn't like about this book—as well as what we can do to make our books better.

Please note that we cannot help you with technical problems related to the topic of this book.

When you write, please be sure to include this book's title and author as well as your name and email address. We will carefully review your comments and share them with the author and editors who worked on the book.

Email: feedback@quepublishing.com

Mail: Que Publishing
 ATTN: Reader Feedback
 800 East 96th Street
 Indianapolis, IN 46240 USA

Reader Services

Visit our website and register this book at quepublishing.com/register for convenient access to any updates, downloads, or errata that might be available for this book.

Main
viewing
area

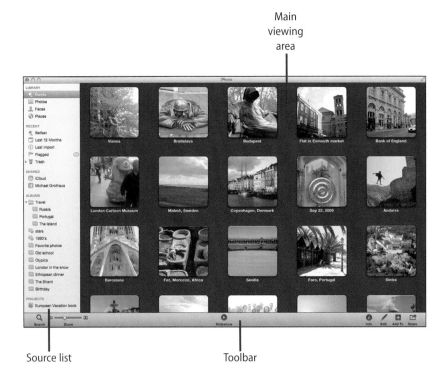

Source list

Toolbar

In this chapter, you learn about all the requirements you need to run iPhoto and use it to its fullest. This chapter also takes a look at the iPhoto interface so you can easily return to this chapter to reference what is where in iPhoto.

→ What is iPhoto?

→ Getting iPhoto on your Mac

→ Keeping iPhoto up to date

→ Exploring the iPhoto interface

What Is iPhoto?

On the surface, iPhoto is a free photo management app for Macs running OSX, but as you delve deeper into the app, you realize iPhoto is different things to different people. That's to say, it's a very versatile app. But versatility does not necessarily mean complicated. After you learn it, you'll see just how simple Apple has made it to use. This chapter first talks about the three primary things iPhoto allows you to do: organize, edit, and share your photos. After that, the chapter shows you how to keep iPhoto up to date and gives you a quick walk-through of its main interface.

iPhoto Lets You Navigate and Organize Your Photos

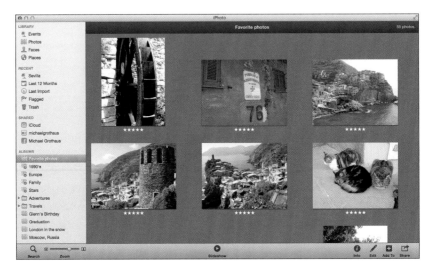

Organizing your photos

In the days before the digital camera, taking and developing photographs were expensive and time consuming. But thanks to camera manufacturers going digital, we can now take a virtually limitless (and free) number of photos. Although the digital camera manufacturers freed us from the chains and expenses associated with old, physical development techniques, the one thing they didn't do is give us a good way to sort through and organize our digitized pics. Thankfully, Apple stepped in and created iPhoto for just that purpose.

Apple realized that although digital cameras were fun and powerful tools, camera manufacturers weren't as good at designing software as they were at creating phenomenal photography equipment. As a result, Apple designed iPhoto to work with any camera on the market. The app enables you to easily plug your camera into your Mac and upload your photos. What's more, iPhoto automatically separates your photos into Events, which are collections of photos based on the time you took them. Furthermore, iPhoto automatically separates your photos into specific albums called Faces and Places, and it lets you navigate through them by the people in the photo or the location where the photo was taken. You'll discover more about Events, Faces, and Places later in the book.

Apple also understands that users want control over their photo organization and navigation. That's why users can easily merge or add to events, create albums, create folders full of albums, and even create smart albums, which are albums that have rules applied, such as "Show me all the photos I've rated four stars."

Furthermore, Apple lets users easily search through their photo libraries using iPhoto's powerful Search and Tagging feature.

iPhoto Lets You Edit Your Photos

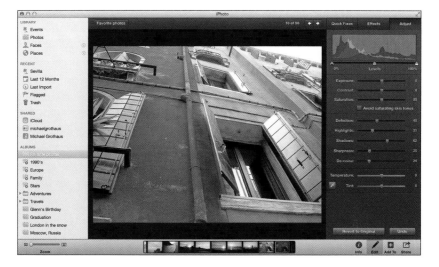

Editing your photos

iPhoto is more than just an organization tool. It's also a powerful photo editor. Using the built-in editing tools, iPhoto can rotate and crop your photos, eliminate red-eye and blemishes with the click of a button, and even straighten crooked pictures.

iPhoto also lets you apply several effects to your photographs, such as lightening or darkening a photo, making it warmer or cooler, and adding sepia tones, vignettes, blurs, and more to your photos. Finally, iPhoto gives you access to complete histogram tools so you can tweak your photos like a pro.

The best (and least known) feature of iPhoto's editing capabilities, however, is that it uses a nondestructive editor, which means that no matter how many times you adjust a photo's color, crop a photo, or apply effects, you

can always return to the original photo with a click of a button. iPhoto accomplishes this by creating and saving an original copy of your imported photograph every time you begin to edit it. It doesn't matter if you've edited a photo a hundred times over a period of years. Simply click Revert to Original and the photograph will look as it did the day you took it.

iPhoto Lets You Share Your Photos

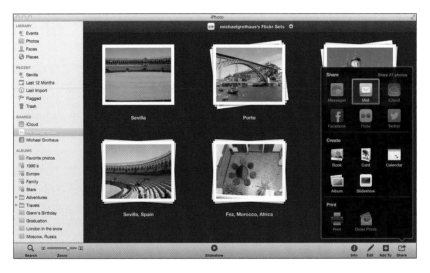

Sharing your photos

iPhoto's organization and editing features are great, but let's be honest—many times you don't take photographs solely for your enjoyment. You also love to share them with your friends and family.

iPhoto enables you to do this through many old-school ways, such as printing a photograph on your printer or emailing a photo to a friend. But iPhoto also makes it possible for you to share your photos in fun and creative new ways.

You can share your photos across the Web via iPhoto's tight social networking integration with Facebook, Flickr, and Twitter. iPhoto also mixes the old with the new because it enables you to easily design slideshows, calendars, books, and cards right in the app. You can then purchase these items within iPhoto and give them to your friends and family as keepsakes.

iPhoto also enables you to access your photos via the cloud with a technology called iCloud Photo Stream. Photo Stream enables you to easily download and share photos you have taken on your iOS devices, such as the iPhone and iPad.

Getting iPhoto

Before you can use iPhoto, you first need to make sure it's on your Mac. If you've bought a new Mac recently, you should have the latest version of iPhoto already on it—iPhoto 9.5, the version this book covers. If you don't have iPhoto, you can buy it through the Mac App Store. Simply launch the Mac App Store from the Applications folder on your Mac, search for **iPhoto**, and then click the Buy button.

iPhoto System Requirements

If iPhoto is already on your Mac, you are good to go. However, if you need to download it (or upgrade to the latest version), make sure your Mac has the following minimum system requirements:

- An Intel dual-core processor.
- A Mac OS X 10.9 (known as Mavericks) or newer operating system.
- At least 2GB of RAM. (4GB or more is recommended for the best experience.)
- At least 5GB of free hard-drive space.

Recommended Extras

Considering the scope of what iPhoto enables you to do, it's also helpful if you have the following extra items. These are not necessary to use iPhoto, but you'll find having them allows you to really take advantage of all the app has to offer.

- An Internet connection
- A digital camera
- An email account
- An iCloud account
- A Facebook account
- A Flickr account
- A Twitter account

Keeping iPhoto Up to Date

Just because you already have iPhoto on your computer doesn't mean you necessarily have the latest version.

Like any good software company, Apple frequently pushes out updates to its applications. These updates typically provide bug fixes or tweaks, but sometimes they even add new functionality to the applications. To make sure you are using the latest version of iPhoto, do the following:

1. Go to the Apple menu in the upper-right corner of your screen.

2. Select Software Update.

3. Software Update opens the Mac App Store to check for any updates to OS X or any apps on your computer, and if it finds any updates, it lists them.

4. Click the Update button if an update is listed for iPhoto (or you can click the Update All button to get the iPhoto update and any others that are available).

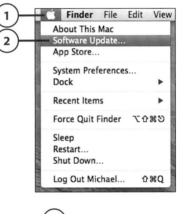

Which Version of iPhoto Do I Have?

To check which version of iPhoto you have, open iPhoto and then from the menu bar at the top of your screen, select iPhoto, About iPhoto. A box opens that shows you the version and build number. This number changes from time to time as Apple pushes out iPhoto updates. This book covers version 9.5 of iPhoto.

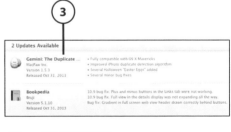

Launching iPhoto

Unless you have removed it, iPhoto's icon always appears in the Dock at the bottom of your screen (or on the sides of your screen if you've moved the dock there). If the iPhoto icon is not in the Dock, navigate to your Mac HD icon on your desktop, and then go to the Applications folder to find iPhoto there.

Click the iPhoto icon once in the Dock to launch it; double-click it if you are launching iPhoto from within the Applications folder in the Finder.

The iPhoto Interface

The good news about iPhoto is that the app has a fairly simple layout. There are no floating palettes or hidden windows you need to regularly access. The editing tools are always available right in the app's window.

What is tricky about iPhoto, however, is that the layout of the app changes slightly depending on what you're doing. For example, while you are editing a photo, you see different buttons and toolbars than you see when you are organizing your photos or creating a book or card.

This book shows you the complete layouts for all the functions in iPhoto in the appropriate sections. For now, however, let's look at how iPhoto appears each time you launch the application.

Main viewing area

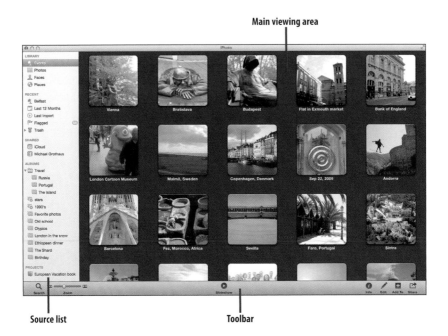

Source list Toolbar

The following sections break down the anatomy of the iPhoto app. As you can see, when iPhoto launches, the application is divided into three primary parts: the main viewing area, the source list, and the toolbar.

The Main Viewing Area

A majority of the screen space of iPhoto is consumed by the main viewing area. It's the dark gray space with all the square images in it. Each square image is an event that contains further photos.

As you can imagine, the main viewing area changes depending on what function iPhoto is performing. When you are editing, the main viewing area shows you the edit screen. When you are creating a calendar, the main viewing area shows you the projects screen. These screens are covered in detail throughout the book.

The Source List

Running down the left side of iPhoto is the source list. You use the source list to navigate through your photos and your organizational structure. This organization includes how you are sharing the photos and any projects you may be working on. The source list is divided into seven sections:

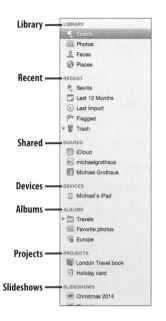

- **Library:** This header consists of four subsections: Events, Photos, Faces, and Places. Select one to navigate your photos using the respective view. Each view is described in more detail later in the book.

- **Recent:** This header consists of five subsections. The top one, labeled Belfast in the image, shows you the *most recent event* you have viewed. Last 12 Months shows you all the photos you have imported in the last 12 months. Last Import shows you all the photos you imported from the last time you connected your camera. Flagged shows you all the photos you have flagged. Trash contains all the photos you have deleted from your iPhoto Library.

- **Shared:** If you are using any of the web-based sharing features of iPhoto, such as iCloud, Facebook, Twitter, or Flickr, your accounts show up here. Read more about web sharing in Chapter 13, "Sharing Your Photos Digitally."

- **Devices:** This header only shows up when you have devices that contain photos plugged into your Mac. It lists any currently connected cameras, iPods, iPhones, iPads and also shows memory cards such as SD cards plugged directly into the computer if they contain photos. Read more about devices in Chapter 2, "Importing Your Photos."

- **Albums:** This header displays all the albums, smart albums, and folders you have created. These albums are covered in Chapter 6, "Working with Albums."

- **Projects:** Any projects, such as cards, books, or calendars, that you have created or are working on are in this section. Chapter 12, "Creating Keepsakes: Books, Cards, Calendars, and Slideshows," covers projects.

- **Slideshows:** Slideshows, unlike other projects, get their own header. You can find any slideshows you make here.

The Toolbar

The toolbar runs along the bottom of iPhoto in the thick gray strip below the source list and the main viewing area. It's divided into three sections: the left, center, and the right. In the left toolbar are the following buttons:

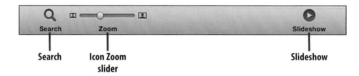

- **Search:** Click the Search button to find photos by title, keyword, description, date, or rating.

- **Icon Zoom slider:** Adjust this slider to increase or decrease the size of the event or photo icons in the main viewing area.

In the center of the toolbar you'll find a single button:

- **Slideshow:** Click the Slideshow button to automatically display a slide-show of your currently selected event or photos.

The right side of the toolbar contains four buttons. These buttons are how you access the meatiest features of iPhoto.

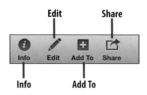

- **Info:** Click Info to bring up a sidebar that displays detailed information about a selected photo, Event, or Faces group. The information can include the camera the photo was taken with, the date and time the photo was taken, a list of people who are in the photo, the GPS coordinates where the photo was taken, and keywords and ratings.

- **Edit:** Click the Edit button to switch iPhoto to Edit mode.

- **Add To:** Click the Add To button to add currently selected photos or events to an already existing album, book, card, calendar, or slideshow.

- **Share:** Click the Share button to share currently selected photos or events with others by uploading them to your iCloud, Twitter, Flickr, or Facebook accounts; by sending them to friends via email or Messages; and by ordering prints or printing them yourself. The Share button also enables you to create an album, book, card, calendar, or slideshow.

Note that these buttons might vary depending on what is selected in iPhoto. For instance, when you select an item under the Device header, only the zoom slider is shown. Also note that one important button that isn't in the toolbar is the Full Screen button. It's in the upper-right corner of the app. Click it to expand the iPhoto app to take up your whole screen.

Connected camera
or device

Selected photos
to import

Import
button

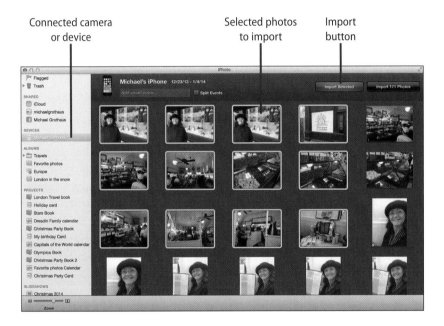

Adding photos to your iPhoto Library is called *importing*. With iPhoto, you can import your photographs several ways. This chapter describes the ways you can import your pictures from various devices.

→ Importing photos from a device

→ Importing photos from a folder or hard drive

→ Importing photos from Mail

→ Turning off automatic imports

→ Dealing with duplicates

→ Finding your iPhoto Library

Importing Your Photos

It used to be that importing photos into a photo application was a big pain. Every different source of the photographs—hard drives, digital cameras, mobile phones—seemed to have a different, complex import process. With the latest version of iPhoto, Apple has simplified that and at least as far as devices go, after you know how to import from one source, you know how to import from the next.

Importing Photos from a USB-Connected Device or SD Card

iPhoto works with virtually any digital camera on the market. Unsurprisingly, this includes all of Apple's iOS devices that offer camera functionality, such as the iPhone, iPod touch, and iPad. As a Mac user, chances are your primary camera will be one of those iOS devices or a dedicated digital camera, which is handy because the import process is the same for all devices.

1. Plug in your iPhone, iPad, iPod touch, digital camera, or card reader to your Mac's USB port, or put the digital camera's SD card into the Mac's SD card reader. The device you have plugged in is listed in the Devices section.

Turn Your Camera On!

If you have your camera plugged into your Mac and iPhoto does not recognize it, make sure your camera is turned on and has battery power. A camera must be powered on and must usually be in View Images mode or configured to enable USB Mass Storage for iPhoto to recognize it.

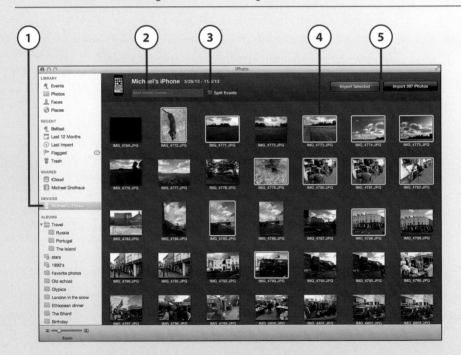

2. Fill in the event name for your import. For example, you might name the photo group "Sally's party" or "Our Anniversary." If you leave this blank, the date will be inserted.

3. Click the Split Events check box to toggle the feature on or off. If you turn on Split Events, a new event is created for each day.

Changing Default Event Times

By default, events are split into 24-hour periods, but you can change the setting by going to iPhoto, Preferences and clicking General in the Preferences window. Under the Autosplit into Events setting, choose One Event per Day or Week, or One Event Every Two or Eight Hours.

4. Select individual photos to import by holding down the Command key and clicking each photo with your mouse, or you can drag a selection box around certain photos.

5. Click either the Import Selected or Import All button to begin your import. The import begins.

6. The blue Import bar indicates how far along your import is. The Import bar also tells you how many photos are left to import. Click Stop Import if you want to cancel the process before all photos are imported.

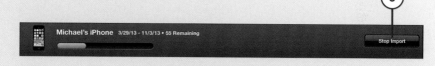

7. Choose to delete or keep the imported photos on the device.

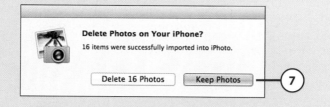

Importing from iCloud Photo Stream

If you're importing from an iPhone or iPad a lot, you don't even need to connect your device to your Mac. Simply enable iCloud Photo Stream in iOS 7 on your iPad, iPhone, or iPod touch by going to Settings, iCloud, Photos and toggling My Photo Stream to On. As long as you also have My Photo Stream enabled in iPhoto (see Chapter 13, "Sharing Your Photos Digitally"), your photos automatically import from your iOS device without connecting it at all.

Importing Photos from a Folder on Your Mac or from an External Device

Another way you can import photos to iPhoto is directly from your Mac or an external device, such as an external hard drive. There are two ways to import photos that are already on your Mac and on external drives.

Use Drag and Drop

The easiest way to import photos that already exist on your Mac or external device is by dragging and dropping them right into iPhoto.

1. Select the photo or folder of photos on your Mac or external device.

2. Drag the selected item into the body of the iPhoto window. The photos are automatically imported and are added to your iPhoto Library.

Copied, Not Moved

Keep in mind that the photos have been *copied* to your iPhoto Library. A copy of the photograph still remains in place on your Mac or external device. You can delete either the original copies or the ones you put into iPhoto without affecting the others.

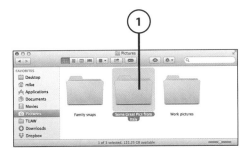

Use the File Menu

If drag and drop isn't your thing, you can import photos from your Mac or external devices by using the Import to Library command from iPhoto's menu bar.

1. Select File, Import to Library.

2. Navigate to the photograph or folder of photos you want to import. These photos could be on your Mac's hard drive or on an external hard drive, CD, DVD, or USB flash drive.

3. Select the photos you want to import, and click the Import button.

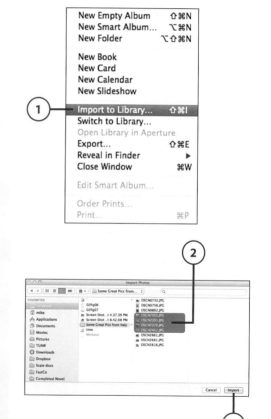

Importing Photos from Apple's Mail App

If you use Apple's Mail app as your email client, you can save photographs people have emailed to you.

1. Open the Mail app.

2. Select an email with photo attachments. From the email header, click and hold the Attachment button. A drop-down menu appears.

3. Select Export to iPhoto. The images import to iPhoto automatically, and iPhoto opens on your computer.

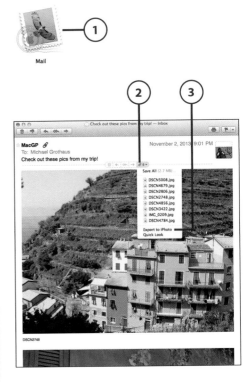

Viewing Your Last Imported Photos

After you choose to keep or delete the photos from your camera, you are taken to the Last Import window. Last Import is a predefined menu item in iPhoto's source list. You can always find it under the Recent header.

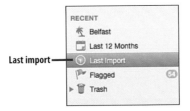

The Last Import window shows you all the photos from your last import, no matter if your last import was three days or three years ago. The photos in the Last Import window are separated into events based on your Autosplit import settings of one event per day, one event per week, or one event per two- or eight-hour gaps.

From the Last Import window, you can double-click the event's name to rename it. Even though you might have already chosen an event name during the original import process, that name is applied only to the topmost event. You must manually name subsequent events. If you have multiple events in the Last Import window, you can drag and drop photos from one event into another.

Turning Off Automatic iPhone, iPod Touch, and iPad Imports

By default, when you plug in a camera via the USB port to your Mac or insert a camera card into a card reader that is connected via USB to your Mac, iPhoto automatically opens and asks whether you want to import any photos that are on the camera or card reader.

One sticky point when connecting an iPhone, iPod touch, or iPad to your Mac is that iPhoto automatically opens. This can be annoying because you might not necessarily want to import photos each time you plug in your iOS device.

You would think Apple would have included an option in iPhoto's preferences for turning off automatic iPhoto launching, but that's not the case. There's no option in the iOS device preferences in iTunes either, which is the primary place you go to choose the setting of how your iOS device works when plugged into your Mac. Oddly, Apple decided to put this setting in an application called Image Capture.

Image Capture is an advanced application that's in the Applications folder on your Mac. It enables you to upload photos from many different sources, such as network drives, scanners, and cameras, to any folder on your Mac. It's also the one place where you can disable the function that makes iPhoto auto-launch when an iOS device is installed.

Disable iPhoto Auto-Launch

1. Open Image Capture while your iPhone, iPod touch, or iPad is connected to your Mac. You can find it in your Applications folder on your Mac.

2. Select your iOS device from under the Devices header in the Image Capture source list.

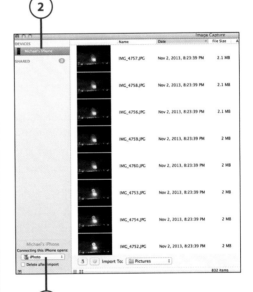

3. Select No Application in the Connecting This iPhone [or iPod touch/iPad] Opens drop-down menu. (By default, it says iPhoto.) If this isn't visible you might need to click the up arrow to make those controls visible.

Importing Photos from iOS Devices

After you have completed these steps, iPhoto no longer opens automatically every time you connect your iPhone, iPod touch, or iPad. When you do want to import photos from those devices, you need to launch iPhoto manually by clicking its icon in the Dock or double-clicking its icon in the Applications folder. Your connected iPhone, iPod touch, or iPad appears in iPhoto's source list.

Dealing with Duplicates

When importing images from a CD or a folder on your computer, or even from a camera where you left the original images on the card after a prior import, you run the risk of importing photographs you've already imported. Luckily, iPhoto has a built-in duplicate detector.

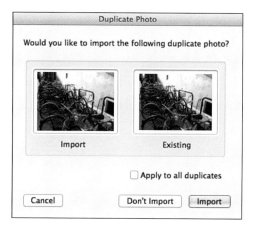

The Duplicate Photo warning gives you the option of reimporting the photograph, which adds another copy of it to your library, or not importing it, which causes iPhoto to skip that single photo and move on to the next. If you check the Apply to All Duplicates check box, iPhoto either imports all duplicates or doesn't import all duplicates in the current import session, depending on whether you then check the Import or Don't Import button.

Understanding Where Your Photos Are Stored

It's important to understand how iPhoto handles file management of imported photographs. When you import an image into iPhoto, by default it is copied to a specific file on your Mac. This file is called iPhoto Library, which is in the User Name, Pictures folder on your Mac.

iPhoto Library file

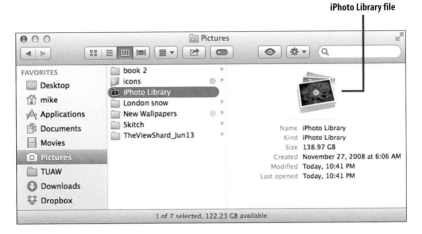

The iPhoto Library file is actually a single database containing all your imported photos organized into a series of folders. These folders preserve the original imported files and also any edits you make.

The advantage of this centralized iPhoto Library file on your computer is twofold:

- It enables you to easily back up your entire photo library by simply copying the iPhoto Library file to an external hard drive.

- It ensures that all the photos on your computer are in one easy-to-find place and eliminates clusters of folders of pictures from being scattered around your Mac.

Disabling the Copy Imported Photos Feature

iPhoto *copies* a photo by default when you add it to your iPhoto Library. This means that when you drag a photo from the Finder into iPhoto, the original photo remains in the Finder. The photo that shows up in iPhoto is a copy of the original file—you now have two copies of the same photo.

If you know you generally prefer to delete the photos from their original locations when you import them, iPhoto gives you the option of turning off the Copy Imported Photos feature in the iPhoto preferences.

1. Click Preferences from the iPhoto menu.

2. Click the Advanced tab.

3. Uncheck Copy Items to the iPhoto Library.

Selected
photo

Photo's
metadata

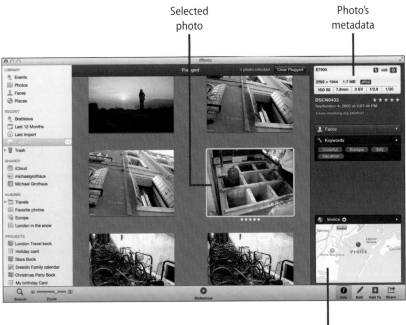

Information
Pane

In this chapter, you learn how to easily view all the extra information, such as shutter speed and aperture, you recorded when taking your photos and how to mark your imported photos by flagging, rating, and adding keywords to them.

→ Learning about iPhoto's Information Pane

→ Changing a photo's name, date, and time

→ Adding and managing keywords

→ Flagging and rating your photos

→ Hiding and deleting your photos

Reading Metadata and Marking Your Photos

When you take a photograph on a digital camera today, you aren't just recording an image. You're also recording dozens of bits of information, or metadata, such as the lens size, the photo resolution, the name of the camera the photo was taken with, the aperture and shutter speed, GPS location coordinates, and more. When you are viewing your photos, this information is of little use. However, when you are organizing and navigating your photos, this information can be invaluable—and you find it all in iPhoto's Information Pane. You can use the information in the Information Pane when you mark or search through your photos.

iPhoto's Information Pane

The Information Pane resides on the right side of iPhoto.

1. Click the Info button in the iPhoto toolbar at the bottom of the screen. Or…

2. …choose View, Info.

3. Alternatively, press Command+I.

Get to Know the Information Pane

The Information Pane gives you a wealth of information about your selected photo. It also displays lots of information for an event or other group of photos. This chapter explains the Information Pane as it relates to one selected photo. It's easiest to learn it that way. Then when later chapters discuss albums and events, you'll already be a whiz at recognizing what the Information Pane is useful for in respect to photo collections.

- **Exif info:** The Information Pane displays the Exchangeable Image File Format (Exif) information, or metadata, of your photo, including the photo's name, the rating you give it, the time and date it was taken, and a description for your photo.

- **Faces bar:** The Faces bar displays a list of names of any faces in your photo. You can also add more faces to this list.

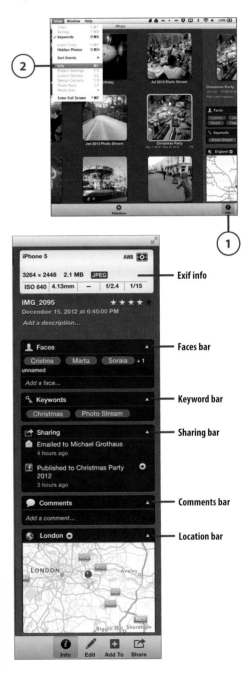

Exif info

Faces bar

Keyword bar

Sharing bar

Comments bar

Location bar

- **Keyword bar:** The Keyword bar enables you to view and add keywords to your photos.

- **Sharing bar:** The Sharing bar shows you where you have shared the selected photo. Shared places and methods include via email, on Facebook, Flickr, iCloud, and more.

- **Comments bar:** The Comments bar shows you comments and "likes" people have left for your selected photo on various social media platforms.

- **Location bar:** The Location bar shows you a map with a pin representing the specific location in the world where you took your photograph. You can zoom in and out on the map.

What Is Exif?

This chapter refers to your photo's Exif information. What exactly is this? Simply put, Exchangeable Image File Format information is a file format that records associated information with the photo being shot.

Exif information is always displayed at the top of iPhoto's Information Pane.

It's Not Mission Critical

If you feel a little freaked out by all the numbers in the Exif information, don't worry! You don't need to know what any of the Exif information means to be a good photographer or enjoy editing and organizing your photos in iPhoto. Apple just added this Exif information to iPhoto's Information Pane for easy reference for those of us who do like to see our photo's Exif information.

1. **Camera name:** This is the name of the camera you took the selected photo with. In this case, it was a Canon PowerShot SD850 IS.

2. **White balance:** The letters AWB signify that the photo was taken using the camera's automatic white balance. White balancing is a technique that ensures what's white in real life shows up as white when you take a picture of it.

3. **Metering mode:** This appears as the crosshairs in a rectangle box in the Exif window. The metering mode tells you the way your camera determined the photo's exposure.

4. **Lens information:** This displays the length of the camera's optical lens, its f-stop, whether it has image stabilization, and more. What is displayed depends on the camera. In this case, iPhoto shows the camera (a Canon PowerShot SD850 IS) had a 5.8–23.2mm lens, but if you were using a more advanced camera—such as the Canon Rebel DSLR kit lens—iPhoto would show more info (such as Canon EF-S 19–55mm f/3.5–5.6 IS).

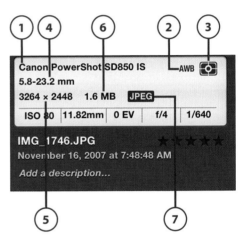

5. **Resolution:** This shows you the resolution of the photo in pixels. The selected photo is 3264 pixels wide by 2448 pixels high.

6. **File size:** This shows the size of the photo. It's 1.6MB in this case.

7. **File type:** This shows the file type of the photo. It's JPEG in this case. Other common formats are TIFF, RAW, and PNG.

8. **ISO:** ISO is a measure of how sensitive the image sensor in the camera is to the amount of light present. The higher the ISO, the more sensitive the image sensor is, which increases the ability to take pictures in low-light situations or at faster shutter speeds in normal lighting. Many cameras allow multiple ISO settings, the trade-off being that higher ISOs have greater amounts of noise.

9. **Focal length:** The focal length determines how much your camera can see. It's the distance between the center of the lens and its focus. In this case, the focal length of the photo is 11.82mm. Also note that in the case of a zoom lens, such as this camera's 5.8–23.2mm lens, the higher number means a higher amount of zoom.

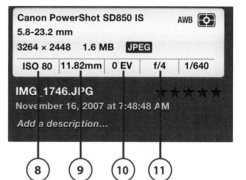

10. **Exposure compensation:** Basically, exposure compensation allows your camera to automatically brighten or darken images so you can get the best picture possible. A number followed by the letters EV designates exposure compensation. In this case, the photo's exposure compensation was 0.

11. **Aperture:** The aperture is the size of the opening in the camera lens while taking a photograph. This limits the amount of light entering the lens. It is designated by f/ followed by a number. The higher the number, the smaller the aperture. Higher numbers mean less light. The aperture in the example is f/4.

12. **Shutter speed:** This is the length of time the camera's shutter is open. Shutter speed is generally longer in night shots because the length of time the shutter is open must be longer in order to take in the appropriate amount of light. The shutter speed of the photo in the example is 1/640—that means the shutter was open for 1/640th of a second.

13. **Filename:** Camera manufacturers use conventional standards when naming photos you have taken. These names often begin with DSC_ or IMG_; in the example, the name the camera assigned to the photograph is IMG_1746.JPG.

14. **Date and time:** This is the date and time you took your photograph. This is the only Exif information iPhoto allows you to alter. You find out how to change this later in this chapter.

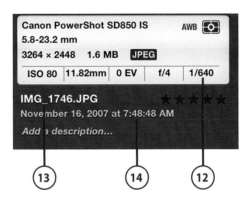

It's Universal

Virtually every camera in the world uses the Exif file format for recording a photo's data. It's a great tool for professional photographers to track their individual shots, but if you're like most iPhoto users, you'll never need to worry about anything you see in the Exif window. But now you know it's there and what it means.

Changing Your Photo's Date and Time

As you'll discover in upcoming chapters, iPhoto is all about organizing and categorizing your photographs. A big way iPhoto helps you do this is with events. For events to work properly, however, your camera must have the correct time and date settings. If it doesn't, when you search through your events, you might see photos that you took last week show up chronologically in the past—way behind photos you took years ago.

Why Are the Date and Time Wrong?

Why might your photos not show the correct date and time? Usually it's because your camera's internal battery ran out of juice. Other causes could be that you never set the correct date and time in the first place or, during long-distance trips, you didn't change your camera's time settings to reflect the date and time of the time zone you were in.

Change a Single Photo's Date and Time

1. Select the photo so a yellow box highlights its edges.

2. Select Photos, Adjust Date and Time. In the dialog box that appears, you see the photo you have selected as well as the original date and time.

3. Enter the new date and time in the Adjusted field. In the dialog box, you are shown by how much the original date and time will be changed.

4. (Optional) Select Modify Original Files if you want to change the date and time to the photo's original file in your iPhoto Library file. Selecting this check box changes the embedded Exif date data. If you don't select this check box, the original Exif data stays the same, and the date change affects the photo only while it's in your iPhoto Library.

5. Click the Adjust button, and the change is made. The new date and time are reflected in the photo's Information Pane.

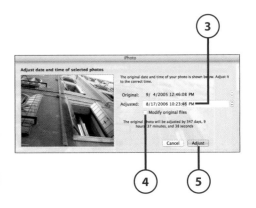

Change Multiple Photos' Dates and Times

You aren't limited to changing the date and time of one photo at a time. You can change the date and time for an entire event or a group of photos.

1. Select the event so a yellow box highlights it. If you are selecting multiple photos, make sure all of the ones you want to change are highlighted.

2. Select Photos, Adjust Date and Time. In the dialog box that appears, you see the first photo of the event or group of photos you have selected as well as the first photo's original date and time.

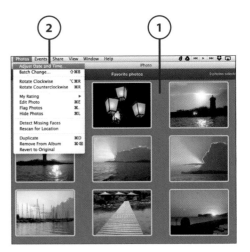

3. Enter the new date and time in the Adjusted field for the first photo. iPhoto uses this date and time to adjust all the other photos accordingly. So, if you change the first photo's time by adding 37 minutes to it, all the photos that you have selected to change will have 37 minutes added to their times. In the dialog box, you are shown by how much the original date and time will be changed.

4. (Optional) Check Modify Original Files if you want to change the date and time to the photos' original files in your iPhoto Library file. Selecting this check box changes the embedded Exif date data. If you don't select this check box, the original Exif data stays the same, and the date change affects only the photos while they're in your iPhoto Library.

5. Click the Adjust button, and the change is made. The new dates and times are reflected in the photo's Information Pane.

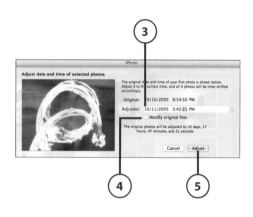

Changing Your Photo's Name

iPhoto gives you the ability to replace the boring filenames your camera assigns your photographs (such as IMG_1842.JPG) to anything you want. If you have tens of thousands of photographs, renaming each one might get tedious, but being able to name individual photos can be very helpful for your favorites, especially when it comes to searching through your library.

A Change Here, No Change There

It's important to note that although this section uses the terms *name* or *file-name*, iPhoto doesn't actually let you change the filename of the photo that is stored in the photo's Exif data. That data is unchangeable. When you change the filename of a photo in iPhoto, you are effectively replacing the name or title iPhoto has given the image (originally taken from the Exif filename) with one of your choosing.

1. Select the photo so a yellow box highlights it.

2. Double-click the photo's filename in the Information Pane to change it to a text entry field. Type any name you want, and press the Return key on your keyboard to finalize it.

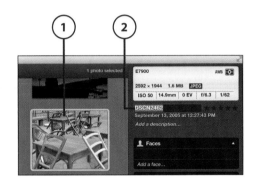

Two Ways to Change a Name

You can also double-click the name of the photo directly under the photo to change it. You won't see the photo's name underneath it unless you've selected View, Titles from the menu bar.

Adding a Description to Your Photos

iPhoto also enables you to add a description to your individual photos. Descriptions are cool because you can record a little blurb about each photo—something to help you remember it by. Descriptions are also helpful when you are searching your iPhoto Library, as you find out later in this chapter.

1. Select the photo so a yellow box highlights it.

2. Double-click the Add a Description text in the Information Pane to change it to a text entry field. Type any description you want. Click outside the text field to finalize it. Note that only the first two lines of description are visible, but if you hover your mouse over it, the entire description pops up in a semitransparent box.

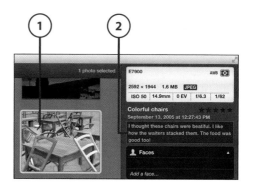

Batch Changing Titles, Dates, and Descriptions

iPhoto offers a Batch Change feature if you find you have hundreds and hundreds of photos to add similar titles, dates, or descriptions to.

1. Select the photos or events so yellow boxes highlight them.

2. Select Photos, Batch Change.

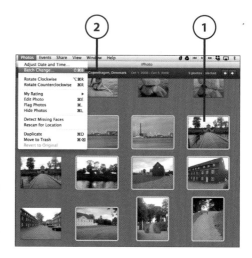

3. Select what you want to change—Title, Date, or Description—from the Set drop-down menu.

4. For Title, you can set the following from the To drop-down menu:

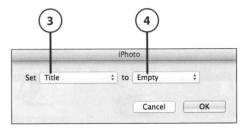

- **Empty:** This clears any previous title name from the photographs.

- **Text:** Any text you enter in the text field becomes the photos' titles. You can check Append a Number to Each Photo to add a sequential number after each one. For example, if you title the photos as "Cool," all the images selected will be named "Cool – 1," "Cool – 2," and so on.

- **Event Name:** This assigns the name of the photo's event as the photo's title.

- **Filename:** This changes the photos' names to their individual filenames from their Exif data.

- **Date/Time:** This changes the titles of each photo to the photos' dates and times.

5. For Date, you can enter the date and time you want the photos to have. Check the Add check box and set the incremental time between each photo.

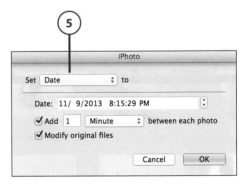

6. For Description, you can enter a short description in the text box. Check the Append to Existing Description check box to add the Batch Change description to any existing descriptions.

7. Click the OK button to finalize the batch change.

iPhoto

Set [Description ⬍] to

You can enter the same description for a number of photos using Batch Change.|

☑ Append to existing Description

[Cancel] [**OK**]

⑥ ⑦

Adding Keywords to Your Photos

Remember how you used to flip a photo over and write on its backside the names of the people who were in it or maybe where it was taken or what the event was? A digital photo has no such backside, but Apple still lets you append labels to it. This feature is called keywords. A keyword is simply a tag or label that you apply to your photographs. These tags come in handy when you are searching for specific photos.

1. Select the photos or group of photos to which you want to add a keyword. You can also select an event to add keywords to. A keyword that's added to an event is added to every photo in the event.

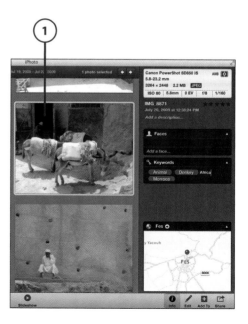

2. Click the Info button to open the Information Pane.

3. Click the Keywords bar to expand the Keywords section of the Information Pane. Click where you see Add a Keyword, and then type your keywords into the Keywords field.

4. Press Return after each keyword. This separates one keyword from the next. A completed keyword is enclosed in a little pill-shaped oval. You can add as many key-words to an event or photo as you want.

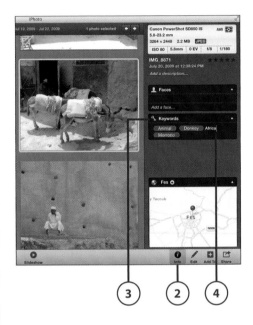

Deleting Keywords

To delete a keyword from a photo or event, simply select the key-word in the Keywords bar and press your Delete key.

Working with the Keyword Manager

Sometimes it's easy to go a bit overboard while adding keywords. For example, if you have a photo of a dog, it's easy to start tagging it with every dog reference you know: "dog," "puppy," "hound," "mutt," and so on. If you ever want to see all the keywords you've created and have the option of editing them, you can find them all in the Keyword Manager.

In the Keyword Manager, you'll see all the keywords you have already added to your photos. You'll also notice some existing keywords Apple has added, such as "Kids" and "Birthday." From this Keyword Manager, you can create, edit, delete, and assign shortcut keys to your keywords.

Create, Edit, and Delete Keywords

Each time you label a photo with the steps in the "Adding Keywords to Your Photos" task, that keyword is added to your keyword store automatically. In other words, you've created a keyword. Another way to create keywords without having to apply them to photos at the time is through the Keyword Manager.

1. Select Window, Manage My Keywords. Alternatively, you can open the Keyword Manager using the Command+K shortcut key.

2. Select Edit Keywords.

3. Click the + button and enter the new keyword in the field that appears.

4. Select a keyword from the list and click the – button to delete that keyword. A window displays to ask, "Are you sure you want to remove the selected keyword?" Below this message, you see how many photos will be affected if you remove the keyword. Deleting a keyword removes that keyword from all the photos that contain it in your iPhoto Library. Click OK to delete the keyword.

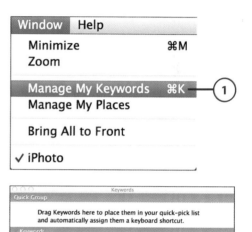

5. Click the Rename button and enter an edit in the text field. Editing a keyword is handy if you've labeled hundreds of photographs with a misspelled keyword. Deleting that misspelled keyword would remove it from all the photos, which means you'd have to go back and retag them with a newly created (and properly spelled) keyword. Editing a keyword enables you to fix spelling mistakes and have the changes automatically apply to all the photos that contain the existing keyword.

6. Click OK when you are done editing keywords.

Add Keyboard Shortcut Keys to Keywords

Keywords are terrific tools; however, adding them to many, many photographs can get rather tedious if you have to repeatedly go through the steps outlined previously. An easier way to quickly add keywords to your photographs is by assigning keyboard shortcuts to your keywords.

1. In the Keyword Manager, click Edit Keywords.

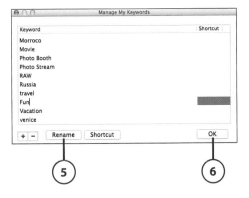

2. Select a keyword you want to create a shortcut for, and click the Shortcut button.

3. Enter a letter representing that keyword in the shortcut field. Usually it's a good idea to use the first letter of the keyword. If a letter is already taken by another keyword, you have the option of choosing which keyword you want to use the letter with. You can also use upper- and lowercase letters for separate keywords—for example, B for birthday, and b for something else.

4. Click OK when you are done adding shortcuts.

WORKING WITH KEYWORDS IN THE QUICK GROUP

>>>Go Further

When you click OK and return to the Keyword Manager, notice that any keywords that have shortcut keys applied to them show up under the Quick Group heading. Next to the keyword, you see its shortcut key enclosed in a gray circle.

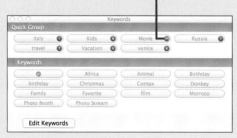

Shortcut key

From the Keyword Manager, you can drag and drop keywords between the Quick Group and Keywords headings. Placing a keyword from the Quick Group heading into the Keywords heading group removes its shortcut key.

Placing a keyword from the Keywords heading into the Quick Group heading group automatically adds a shortcut key to the keyword. The automatically added shortcut key is the first letter of the word. If that letter is already taken, the second letter of the keyword is used, and so on.

Apply Keywords Using Keyboard Shortcut Keys

After you have your keyboard shortcuts assigned to keywords, you can quickly assign keywords to your photos.

1. Move the Keyword Manager window aside so you can see your photograph in iPhoto.

2. Select your photographs and click the appropriate shortcut key to assign that specific keyword to the photo or group of photos.

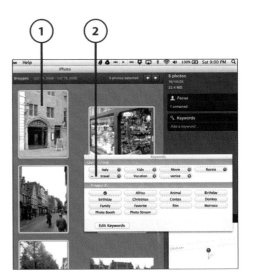

Shortcuts for Shortcuts

There are more ways to use keyboard shortcuts without opening the Keyword Manager and clicking them. For example, you can also simply press the assigned key for the shortcut (along with any modifier key) right on your keyboard. Another way to enter keywords using shortcuts is in the Keywords section of the Info panel. Click in the Keywords section and press the letter key assigned to a shortcut. It gives you the option of continuing to type a new keyword or choose the one mapped to that shortcut key.

Flagging Your Photos

Similar to how adding keywords to photos duplicates the experience of writing words on the backside of paper photographs, flagging your photos in iPhoto is the equivalent of placing a selected photo to the side in its own special pile while you browse the rest of your photos.

Flag a Photo

1. Select the photo and click the Flag Indicator in the photo's upper-left corner. Note that the flag indicator does not appear in the corner of a photo until you move your mouse over it.

Raising the Flag

You can also flag a photo (or multiple photos) by choosing Photos, Flag Photo from iPhoto's menu bar.

2. When you flag a photo in iPhoto, it is added automatically into a special Flagged photo album that always exists under the Recent header in iPhoto's source list.

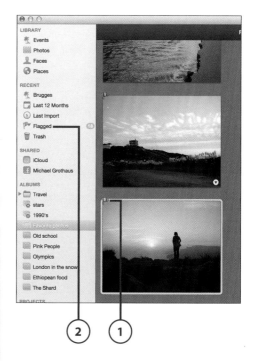

Unflag a Photo

1. Select the already flagged photo or photos and click the Flag Indicator in the photo's upper-left corner.

Removing a Flag

You can also unflag a photo (or multiple photos) by choosing Photos, Unflag Photo from iPhoto's menu bar. The photos are removed from the Flagged photo album automatically.

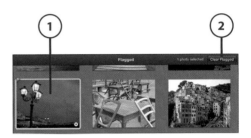

2. If you want to unflag all flagged photos in your iPhoto Library, select the Flagged album from the source list and then click the Clear Flagged button at the top of the album, or hover your mouse over the flagged photos number indicator in the source list and click the X that appears.

>>>Go Further

WHY FLAG PHOTOS?

So, why flag a photo? Here are some times flagging comes in handy:

- When deciding to delete some photos, you can flag redundant ones so they are easy to find and review later.

- When selecting photos for a project, such as a calendar or book, flag them to easily group photos from across events and albums into one quick list—the Flagged album.

- When selecting photos from across multiple events or albums, flag them to combine them into one event or add them to another album.

- When you're thinking about ordering prints of some photographs, or choosing which ones to print yourself, flagging helps you keep track of your top choices.

Rating Your Photos

iPhoto enables you to assign ratings to your photos so you can record how much you like each one. iPhoto's rating system is based on zero to five stars. Rating your photos isn't just something you do to pass the time. Rating them can help you easily search through your library or create photo albums based on your ratings.

You have five ways to rate your photos, four of which are discussed in this task. (Read about the fifth way in the "Using the Contextual Menu" section later in this chapter.) Like most other marking options in iPhoto, you can rate one photo at a time or group multiple photos together to rate them.

1. Select the photo or photos you want to rate.

2. From iPhoto's menu bar, select Photos, My Rating and choose None or one to five stars. Or…

3. …from iPhoto's Information Pane, click and drag your mouse over the hollow stars to rate the photo. Or…

4. …from underneath a photo, click and drag your mouse over the hollow stars to rate the photo. (To view ratings underneath photos, you must make sure you have selected View, Ratings from the menu bar.) Or…

5. …from your keyboard, press the Command key on your keyboard and then 0, 1, 2, 3, 4, or 5 to rate the selected photos between zero and five stars.

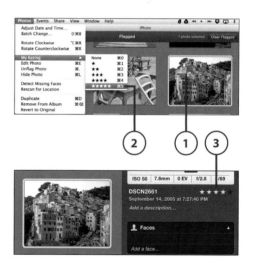

Hiding Your Photos

iPhoto gives you the ability to hide certain photos. I know, all of your photos are amazing, so why would you want to hide any of them? Hiding is useful when you are thinking about deleting photos but aren't quite sure if you want to do that. In the meantime, choosing to hide photos removes them from view in your iPhoto Library.

Hide a Photo

1. Select the photo or photos you want to hide.

2. From the menu bar select Photos, Hide Photo.

3. The photos are removed from viewing, and at the top of iPhoto's window you are notified of how many photos are hidden in the particular album, Event, Faces, or Places.

Temporarily View Hidden Photos

1. Select View, Hidden Photos. This does not unhide the photos because they are still marked as hidden. This simply shows you all the photos you have hidden.

2. Hidden photos in this view are marked with an orange X in their upper-right corners. If you select View, Hidden Photos again, the photos you have marked as hidden vanish from view again.

Unhide a Photo

1. Select your hidden photos.

2. Choose Photos, Unhide Photos.

Deleting Your Photos

At times, you might decide to delete some of your photographs. This can be for several reasons. Perhaps the shot is blurry. Maybe the photo is similar to dozens of others you've taken of the same thing. Whatever your reason, you want to get rid of it.

Move Photos to the Trash

1. Select the photo or photos you want to delete.

2. Press the Delete key on your keyboard, or choose Photos, Move to Trash.

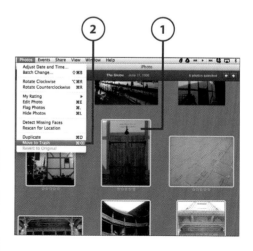

3. Click Delete Photos in the confirmation box.

4. At this point, you haven't actually deleted your photos from iPhoto. You've just moved them to iPhoto's trash can. iPhoto's trash can icon is always in the source list. Hovering your mouse over the trash can icon displays a small window that shows you how many photos you have in the trash.

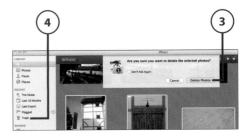

About Trashing Photos

Moving a photo to iPhoto's trash removes that photo from all albums, events, and projects that photo appeared in—including any books, cards, or calendars you may have created. If you shared the photo online via Flickr, iCloud, or Facebook, it remains there until you remove it.

Restore Photos from the Trash

If you've changed your mind and don't want to delete your photos or a few select photos you've moved to the trash, you can choose to restore your photos to your iPhoto Library.

1. Select the trash icon in the source list.

2. Select the photo or photos.

3. Choose Photos, Put Back. Your photos are placed back in the albums, events, and projects in which they were located before you moved them to the trash.

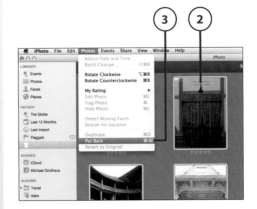

Permanently Delete Photos

1. Select Trash in the source list, and click the Empty Trash button.

2. Click OK in the dialog box that asks whether you are sure you want to delete the photos permanently.

Trash Technicalities

Technically you have deleted the photos from your iPhoto Library file on your computer. However, until you empty your computer's trash can by choosing Finder, Empty Trash, your photos remain on your computer, albeit in the trash can. After you empty your computer's trash, your deleted photos are really, truly gone forever unless you have backed them up.

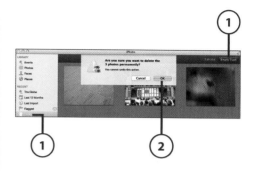

Using the Contextual Menu

You can also access many of the operations reviewed in this chapter by using a contextual menu built in to iPhoto. To access this contextual menu, move your mouse over a photograph and right-click. (Optionally, you can click the tiny downward-facing arrowhead that appears in the lower-right corner of a photo.)

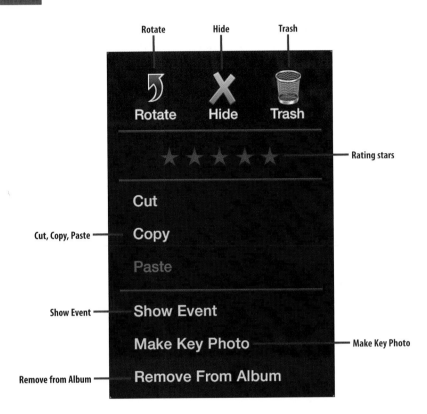

- **Rotate:** Click this arrow to rotate the selected photo counterclockwise 90 degrees at a time. This is great for easily fixing photos to show right way up in the iPhoto Library.

- **Hide:** This is another way to hide a photo. Simply click the orange X.

- **Trash:** Click the trash can icon to move the photo to iPhoto's trash.

- **Rating stars:** Click and drag your mouse over these stars to rate the photo.

- **Cut, Copy, Paste:** Click these commands to cut or copy the selected photo or paste a previously copied photo.

- **Show Event:** If the photo is in an album, clicking this takes you to that photo's event.

- **Make Key Photo:** Click this command to make the selected photo an event's key photo. You can read about key photos and events in Chapter 5, "Working with Events."

- **Remove from Album:** Click this command to remove the photo from the selected album.

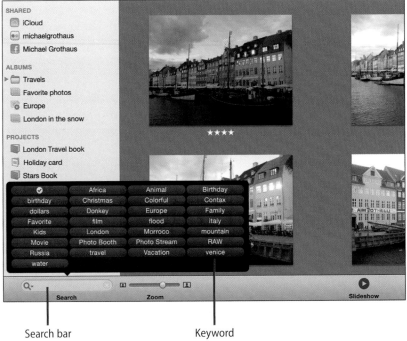

Search bar

Keyword
search tools

In this chapter, you learn all the ways you can search through your photos in your library.

→ Searching by text
→ Searching by date
→ Searching by keyword
→ Searching by rating

Searching Your Photos

iPhoto offers you powerful search capabilities. It allows you to search your photos using many of the things you've learned about in the previous chapter as parameters, including photo names and descriptions, EXIF information such as dates, and keywords and ratings.

If you are just starting out with iPhoto or digital photography, your iPhoto Library may be quite small, meaning you hardly use search. However, as your iPhoto Library grows, search will become an important tool you'll use more and more.

NARROWING YOUR SEARCH

Before you begin your search, it is important to note that if you know where the photo that you are looking for might be located—such as in a certain event or album—select that event or album before clicking the Search button. Doing so narrows down the location iPhoto searches for photos to only that event or album. To search your entire library, select Events or Photos from iPhoto's source list.

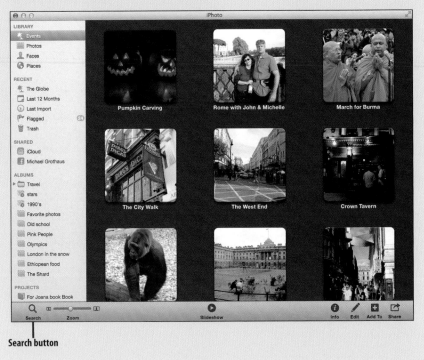

Search button

iPhoto's Search button is in the toolbar at the bottom-left corner of the screen. It, appropriately enough, looks like a magnifying glass. When you click the Search button, it changes to a Search field. Inside this Search field, you see a search menu icon that looks like a smaller magnifying glass. When you click the icon, you see four search options: All, Date, Keyword, and Rating.

Searching by Text

Apple really should have named the All search menu option Text because that's what it does—it enables you to search for text associated with a photo, including names, keywords, and descriptions.

1. Click the Search button in the iPhoto toolbar.

2. Click the magnifying glass icon in the text field so the pop-up menu appears.

3. Click All.

4. Enter the text you want to find in the Search field.

5. As you enter text, the body of iPhoto's window populates with those photos that match your search term.

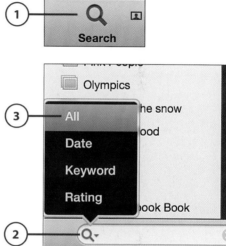

iPhoto's Search Is Dynamic!

iPhoto's search is dynamic. That means if you start typing *"HOLIDAY"* one letter at a time, photos with the letters *HO*, such as Holland, appear alongside photos with the words holiday associated with them. When you type in *HOLI*, those photos labeled *Holland* disappear, yet those labeled *Holiday* remain.

6. Click the *X* to clear the search field of text.

Searching by Date

iPhoto allows you to search photos by date in four different ways: by year and month, by specific date, by range of consecutive dates, and by nonconsecutive dates.

Search for Photos by Date

1. Click the Search button in the iPhoto toolbar.

2. Click the magnifying glass icon in the text field so the pop-up menu appears.

3. Click Date.

4. A calendar pop-up window with the year and months displays.

5. Navigate the years by clicking the left and right arrows in the pop-up menu.

Having a Gray Month?

Months that are grayed out have no photos taken during that time in your iPhoto Library. Months in white have associated photos taken during that time.

6. Click the month name to view photos taken during that month.

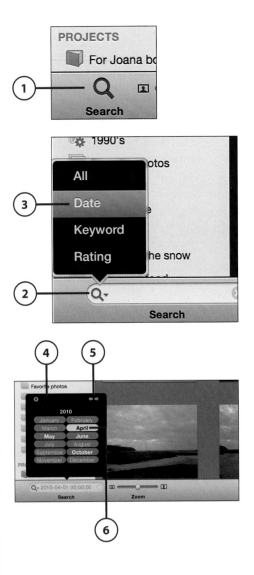

Search for Photos by Specific Date

1. Click the Search button in the iPhoto toolbar.

2. Click the magnifying glass icon in the text field so the pop-up menu appears.

3. Click Date.

4. A calendar pop-up window with the year and months displays.

5. Navigate the years by clicking the left and right arrows in the pop-up menu.

6. Double-click the month with the specific date you want in it. A daily calendar displays.

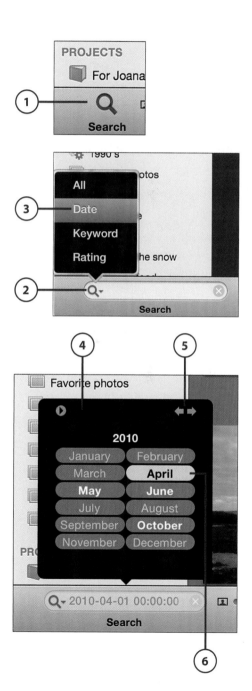

7. Click a specific date on the daily calendar to see the photos taken on that date only.

8. Click the arrowhead in the circle at the top left of the pop-up menu to return to the month view.

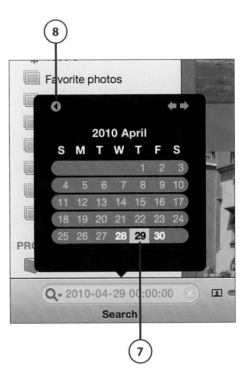

Search for Photos by Consecutive Date Range

1. Click the Search button in the iPhoto toolbar.

2. Click the magnifying glass icon in the text field so the pop-up menu appears.

3. Click Date.

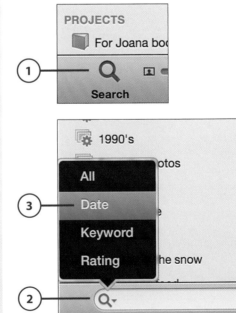

4. A calendar pop-up window with the year and months displays.

5. Navigate the years by clicking the left and right arrows in the pop-up menu.

6. Click the month (or day) with the specific date you want to start your search and then navigate through the calendar until you find your ending date range.

7. When you find your ending date range (month or day), click it while holding down the Shift key. iPhoto displays all the photos in the date range you selected.

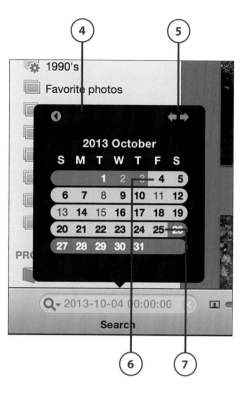

Search for Photos by Nonconsecutive Dates

1. Click the Search button in the iPhoto toolbar.

2. Click the magnifying glass icon in the text field so the pop-up menu appears.

3. Click Date.

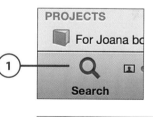

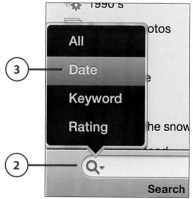

4. A calendar pop-up window with the year and months displays.

5. Navigate the years by clicking the left and right arrows in the pop-up menu.

6. Find the first month (or day) of the time period you want to include in your search and click it.

7. Keep adding additional dates, months, or years by holding down the Command key when you click them. As you add more dates, iPhoto displays all the photos taken on the nonconsecutive dates you've selected.

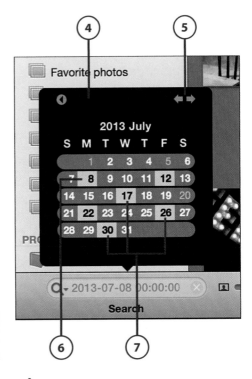

Searching by Keywords

Now that you are getting familiar with iPhoto's search functions, you can see why keywords can be a powerful search tool as they enable you to quickly find a specific photo by a word you chose to tag it with.

1. Click the Search button in the iPhoto toolbar.

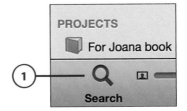

2. Click the magnifying glass icon in the text field so the pop-up menu appears.

3. Click Keyword.

4. A list containing all your keywords appears as a pop-up menu.

5. Hover your mouse over a keyword in the list to see a number displayed that shows you how many photos are tagged with that keyword.

6. Click the keyword, and the photos appear in iPhoto's body. Note that the clicked keyword button turns to white.

7. If you click another keyword, it also changes into a white button. Clicking two or more keywords shows you only the photos with all of those keywords in them. To search for photos using a single keyword, make sure you click any white keyword buttons to deselect them.

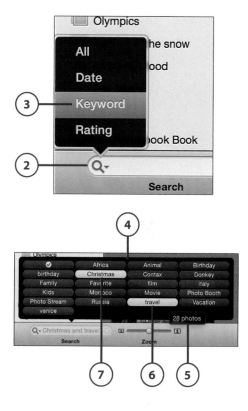

Advanced Keyword Searching

iPhoto has some pretty nifty advanced keyword searching features built in. The app lets you use keyboard keys as logical operators. In other words, you can search for photos containing some keywords but exclude those same photos from your search results (if they contain certain keywords as well).

Let's say you have lots of photos labeled "water." Some of these water photos show pictures of flood damage to your basement (which you've tagged using the keywords "water," "house," "insurance," and "flood"). Others show the lake you vacationed at in Switzerland last summer (keywords: "water," "vacation," "lake," "summer," "Europe"). Still more show pictures you took of the Mediterranean Sea (keywords: "water," "sea," "vacation").

So, you're searching for all your photos that contain water, but you want to exclude the pictures of the flood damage to your house. Use the following logical operator keys to construct the keyword search:

- Shift key = "OR"

- Option key = "NOT"

- Control key = "AND"

1. Click the Search button in the iPhoto toolbar.

2. Click the magnifying glass icon in the text field so the pop-up menu appears.

3. Click Keyword.

4. A list containing all your keywords appears as a pop-up menu.

5. Click the keyword "water." The pictures of your flooded basement, the lake, and the Mediterranean appear.

6. Click the keyword "flood" while holding down the Option key. This eliminates all the photos from the "water" search that also contain the keyword "flood." Now you're left with the pictures of the lake and the Mediterranean.

7. Hold down the Control key and click the keyword "Mountain." This tells iPhoto you want to search for all photos containing "water" and "mountain" but not "flood."

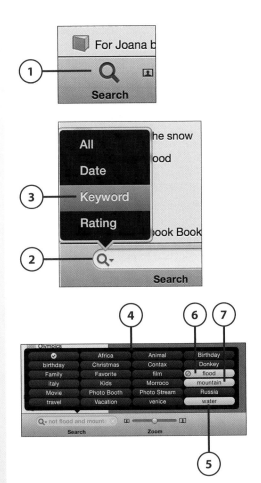

Searching by Ratings

The last way to search your photos is by ratings. This is my favorite way because it's the simplest and also it quickly shows you your favorite snapshots.

1. Click the Search button in the iPhoto toolbar.

2. Click the magnifying glass icon in the text field so the pop-up menu appears.

3. Click Rating. Five hollow stars display in the search field.

4. Progressively click the number of stars for the rating you want to search for. For example, if you want to search for four-star photos, click the fourth star. iPhoto displays all the photographs that have a rating of four stars or higher.

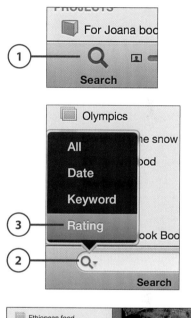

Events
header

An individual
event

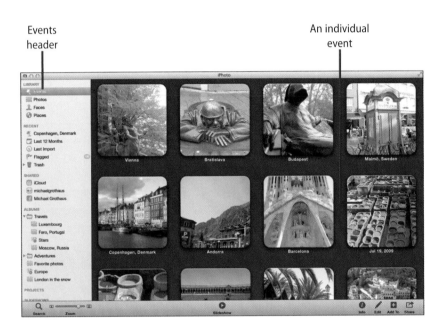

In this chapter, you learn all the ways you can organize your photos by events.

→ Viewing event information
→ Setting and changing key photos
→ Creating new events
→ Merging and splitting events

Working with Events

The great thing about digital photography is that you can take as many photos as you want because you are no longer constrained by the cost of buying and developing film. However, taking more pictures than you may ever need can make organizing and navigating your photographs a chore.

Luckily, iPhoto lets you keep your photos organized with zero effort on your part. It does this by using the Events feature. So, what is an *event*? It's a collection of your photographs that spans a certain time frame, automatically grouped by iPhoto upon import from your camera. By default, every time you import photos from your camera, iPhoto sorts them into events based on the day they were taken.

Changing Events Autosplitting Time Frame

iPhoto calls the sorting of your photos by date or time frame *autosplitting*. So if you import photos that were taken over a period of three days, iPhoto sorts, or autosplits, those photos into three separate events. However, you can change the default timespan iPhoto chooses to split events into.

1. Choose Preferences from the iPhoto menu bar.

2. Click the General tab.

3. From the Autosplit into Events drop-down menu, choose to have iPhoto group imported photos by one event per day, by one event per week, or into two-hour or eight-hour gaps.

Times Are A'Changing

Changing events' autosplitting time window from one event per day to two- or eight-hour gaps is handy if you were running around and took photos in several different locations on the same day. Provided there was at least a two-hour window between the times you took the photos at those different locations, you have a better chance of iPhoto sorting those locations into their own events.

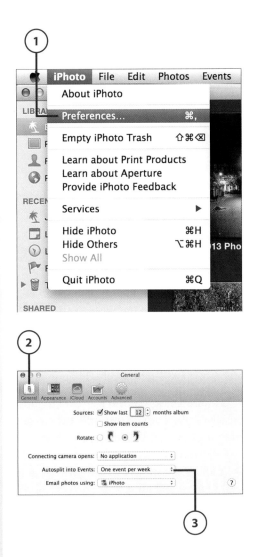

Viewing Event Information

After you've imported your photos, they appear as events in the main body of iPhoto's window when you have Events selected in iPhoto's source list. Notice that your events are arranged one after the other as a series of squares with rounded corners. There are a few ways you can interact with events at this level.

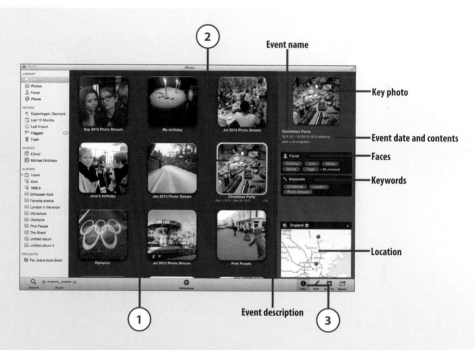

1. Move your mouse's cursor horizontally over an event to flip through the thumbnails of all the photos in that event in sequential order.

2. Double-click an event to be taken inside of it and see all the photos it contains.

3. Click the Info button in iPhoto's toolbar to get more information about the selected event. The event's Information Pane shows you the following information:

 - **Key photo:** The key photo is the photo that represents the event. It's a single photo from all the photos contained in the event.

 - **Event name:** By default, the event is named after the date when the photos were taken. You can change the name of the event just like you would change the name of a single photo. Click its name in the Information Pane, and type in any name you want. You can also change the event's name by clicking its current name below its thumbnail in the Events window.

- **Event date and contents:** Below the event's name is the date or date range of the photos contained in the event. The number of items contained in the event is also displayed.

- **Event description:** You can write a short summary of the event here if you want.

- **Faces:** The Faces bar tells you who is in the photos contained in the event.

- **Keywords:** This lists all the keywords of the photos contained in the event. You can add additional keywords by clicking in the Keyword field. Adding a keyword to an event adds that keyword to every photo in the event.

- **Location:** The map at the bottom shows you the locations where the photos were taken.

Setting an Event's Key Photo

Each event has a key photo that visually represents all the photos in that event. By default, an event's key photo is chosen by iPhoto, and it is always the first photo in the event. However, you can change any event's key photo—and you probably should. To change an event's key photo, you have five options:

A Good Photo Is Key

Selecting a good key photo is—excuse the pun—key. A good key photo lets you recognize an entire group of photos just by seeing that one image. For example, if you took your kids to the pumpkin patch, your first photo might have been of an ear of corn; however, a more representational photo of the event would probably be the one you took of a huge pumpkin.

1. With events selected in the source list, run your mouse over any event so you are skimming through the event's photos. When you find a photo you like, stop skimming and press the spacebar on your keyboard. This sets the selected photo as the key photo. Or…

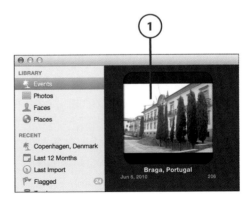

2. …with events selected in the source list, run your mouse over any event so you are skimming through the event's photos. When you find a photo you like, stop skimming and right-click. From the contextual menu that appears, select Make Key Photo. *Or…*

3. …select an event so a yellow box highlights it. In the event's Information Pane, skim your mouse over the event so its photos are displayed one after another. Click the photo you want to set as the key photo. *Or…*

4. …double-click an event to view its contents. Scroll through the photos in the event, and when you find the one you want to make the key photo, right-click it and from the contextual menu that appears, select Make Key Photo. *Or…*

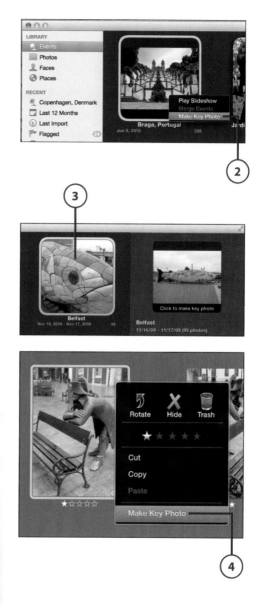

5. ...double-click an event to view its contents. Scroll through the photos in the event, and when you find the one you want to make the key photo, select Events, Make Key Photo.

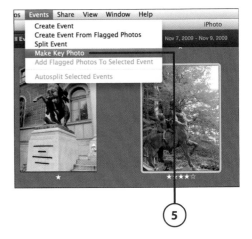

Creating New Events

You aren't limited to only the events iPhoto has automatically created for you. iPhoto gives you the power to create new additional events based on three criteria: creating events using specific photos, creating events using flagged photos, and creating empty events.

Create a New Event Using Specific Photos

Creating events using specific photos enables you to easily combine photos, no matter where you took them or the length of time between taking them, into a single event.

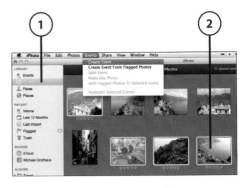

1. Select Photos in iPhoto's source list. The Photos list shows you every single photo in your library regardless of what event or album it is located in.

2. Select the photos you want in your new event. To select a group of photos, click and drag your mouse over a selection of them.

To select photos that are not near each other in the library, hold down the Command key on the keyboard, and click each desired photo so that a yellow box highlights them.

3. Choose Events, Create Event from the menu bar. You see a confirmation dialog box.

4. Click Create.

5. A new event is created in your Events list. The new event is named based on the date of the first photo in the event, so you might need to scroll through your Events list to see the new event if the first photo was taken well in the past.

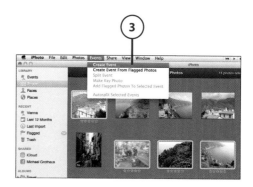

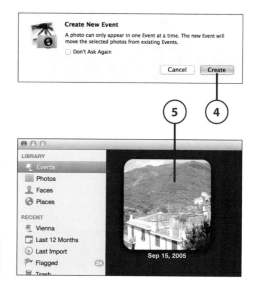

Create a New Event Using Flagged Photos

You can quickly create a new event using the photos you have previously flagged.

1. Make sure you have flagged the photos you want in your new event.

2. Choose Events, Create Event from Flagged Photos. You see a confirmation dialog box.

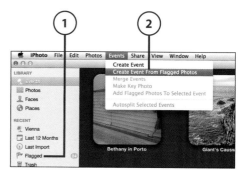

3. Click Create.

4. A new event is created in your Events list. The new event is named based on the date of the first flagged photo in the event, so you might need to scroll through your Events list to see the new event if the first photo was taken well in the past.

5. By default, the new event is called Untitled Event. Double-click it to rename it.

Create an Empty Event

You can create an empty event and then fill it with photos of your choosing at a later time.

1. Make sure you have selected events in the source list.

2. Make sure no events are selected in the main viewing window. You can quickly deselect an event by clicking in the empty space between events.

3. Choose Events, Create Event.

4. A placeholder event thumbnail appears in your events labeled New Event. As you can see, the event's key photo is actually just a thumbnail of a black-and-white palm tree and sunset.

5. Add photos to this empty event by dragging and dropping them into it.

Merging Events

Merging events is a cool feature that enables you to combine two or more events into one. This is handy if you frequently visit and photograph the same location many times a year. For example, I have several events with pictures of London. I can combine them into one event so I can see all of them in one place. Another reason you might merge events is to assemble all of your kid's birthday photos from their parties over the years into one event.

1. Select events in iPhoto's source list.

2. Select two or more events you want to merge. You can drag a box around events that are near each other to select them or hold down the Command key on the keyboard to select events that are further away. You can also hold down the Shift key and click multiple events to select a range of events.

3. Choose Events, Merge Events. *Or…*

4. …right-click any of the selected events and choose Merge Events from the contextual menu. You see a confirmation dialog box.

5. Click Merge.

Merging by Dragging

You can also merge two events by simply dragging one event on top of another event. Doing so adds all the photos of the dragged event to the stationary event. The name and key photo of the stationary event is the one used for the merged photos.

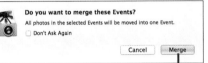

Splitting Events

Just as you can merge two events into one, you can split one event into two. This is really handy if you've been importing your photos using "one day" for the event autosplit settings and now want to divide that day's photos into more manageable chunks.

1. Select events in iPhoto's source list.

2. Double-click the event you want to split so you can see the photos in that event.

3. Find and click the photo that you want to be the start of a new event. All photos that appear after this photo are added to the new event. If you want to split an event using nonadjacent photos from the event, hold down the Command key on the keyboard and click the individual photos you want to split off from the main event.

4. Choose Events, Split Event.

5. You can see the results of an event split. In this example, the Morocco event was split. All the photos before the split remain in the original event.

6. Below the orginal event is the newly split event, titled Untitled Event.

7. Double-click Untitled Event to rename it.

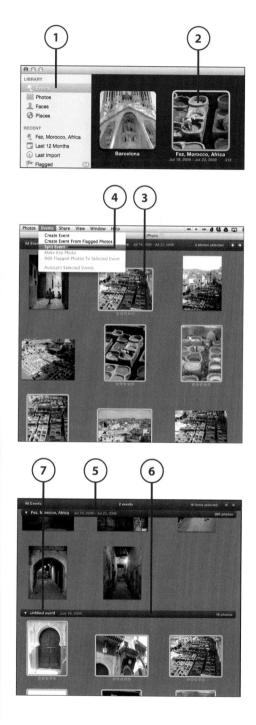

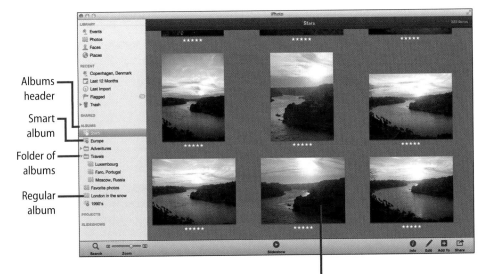

Albums header

Smart album

Folder of albums

Regular album

Contents of selected album

In this chapter, you discover all the ways you can organize your photos by albums and smart albums.

→ Creating regular albums

→ Creating smart albums

→ Creating folders to organize your albums

→ Sorting your albums

Working with Albums

For those of you who like manually organizing your photographs, iPhoto offers you the option of sorting your photos into albums and smart albums.

At first glance, it's a bit hard to tell the difference between an event and an album. After all, they are both ways of organizing your iPhoto Library and can contain multiple photos. So, what are the differences between the two?

- An individual photo can be contained in only one event, but the same photo can be placed in multiple albums.

- Photos in an event are arranged by their import sequence; you can't manually arrange them. With an album, you can arrange the photos in any order you want.

Albums are great because you can create an unlimited number of them to suit your needs. You can arrange and sort your photos how you like, add or remove photos without affecting their other locations in your iPhoto Library, and put the same photo in two or more places at once.

No Duplicate Files

No matter what, iPhoto does not keep two copies of your photos when you move them. If you have the same photo in three different albums, you still have only one copy of that photo in your iPhoto Library. When you place a photo in an album, you are effectively telling iPhoto to reference the photo from the main iPhoto Library.

Regular Versus Smart Albums

iPhoto lets you create two kinds of albums: regular and smart. Both types are similar in that they contain your photographs, but how you get photos into a regular album and a smart album differs greatly.

A regular album in iPhoto can contain any photo you manually add to it. Regular albums are great for grouping your favorite vacation shots or perhaps making a collection of photos that you want to burn to a CD and send to your grandma.

A smart album in iPhoto automatically groups any photos that match the criteria you set. For example, you might create a smart album to contain all the photos you have rated five stars. With a five-star smart album created, not only are you able to view all your five-star photos instantly, but also any photo you rate with five stars in the future is automatically added to that smart album.

All albums—both regular and smart—show up beneath the Albums header in iPhoto's source list. Depending on what you've created, you'll find the following here:

- **Folders:** Represented by a small gray folder icon, a folder can contain multiple albums. Folders enable you to group related albums, both regular and smart, together.

- **Regular albums:** A regular album is represented by an icon that looks like the outline of a photograph. Regular albums contain any photos you've manually dragged there.

- **Smart albums:** The outline of a photograph with a cog in the corner represents a smart album. They contain your photos based on predefined search criteria.

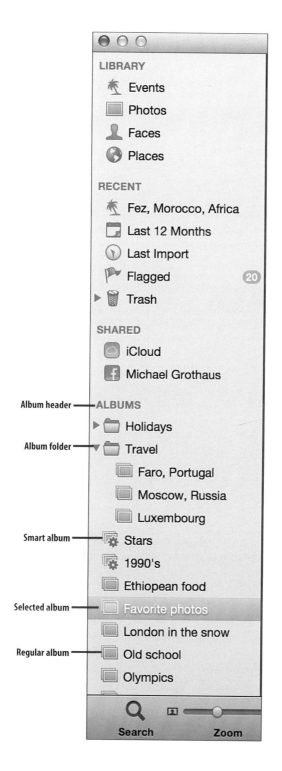

Album header — ALBUMS

Album folder — Travel

Smart album — Stars

Selected album — Favorite photos

Regular album — Old school

Creating Regular Albums

iPhoto lets you create a regular album in a variety of ways. You can create empty albums, which you can then later populate at will, or you can create albums from currently selected events or photos, or from a folder of photos on your Mac's hard drive.

Create an Empty Album

1. Choose File, New Album, but then hold down the Shift key so New Album becomes New Empty Album and click it.

2. Your new album appears in the source list with the name Untitled Album. You can rename it to whatever you want.

Why Are All My Photos in My New Album?

If you forget to hold down the Shift key while choosing File, New Album, you will still create a new album, but it will be populated with every single photo in your library. You can Select All (Command+A) and press the Delete key to remove the photos to clear the album, or just select the album in the source list and press the Delete key to delete the album entirely. The photos are still in your iPhoto Library.

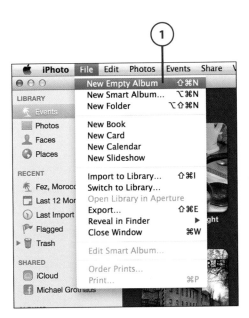

Create an Album from Selected Photos or Events

With iPhoto, you can select a group of photos, or entire events, and quickly create an album containing those photos. This is handy when you are browsing your photo library and see a collection of photos you'd like to group into its own album. It eliminates the need to create an empty album first and then drag the photos in later.

To create an album from selected photos or events, you have four options.

The Menu Bar

1. Select the photo, photos, or events you want to create an album from.

2. Select File, New Album.

3. A new album containing the selected photos appears. You can begin typing to rename it. (By default the name is "untitled album.")

The Source List

1. Select the photo, photos, or events you want to create an album from.

2. Drag the selected photos to iPhoto's source list.

3. A new album called "untitled album" containing the selected photos appears. Begin typing a new name to rename it.

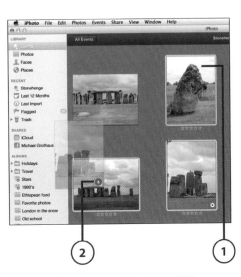

The Add To Button in the Toolbar

1. Select the photo, photos, or events you want to create an album from.

2. Click the Add To button.

3. Select Album from the pop-up menu.

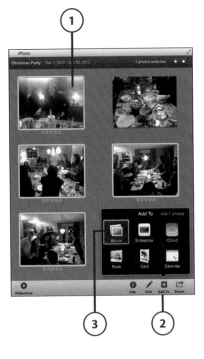

4. Select New Album from the expanded pop-up.

5. A new album called "untitled album" containing the selected photos appears. Begin typing a new name to rename it.

The Share Button in the Toolbar

1. Select the photo, photos, or events you want to create an album from.

2. Click the Share button. It looks like an arrow breaking out of a box.

3. Select Album from the Create menu.

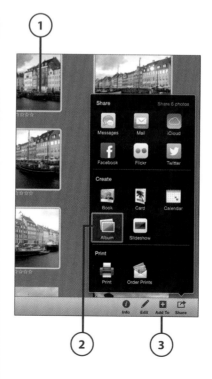

4. A new album called "untitled album" containing the selected photos appears. Begin typing a new name to rename it.

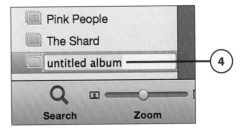

Create an Album from a Folder on Your Mac

If you have a folder full of photos on your Mac, you can quickly import them to your iPhoto Library and create an album at the same time.

1. Find the folder of photos on your Mac and drag it to Albums in your iPhoto source list.

2. The Import process begins; just wait and let it do its thing.

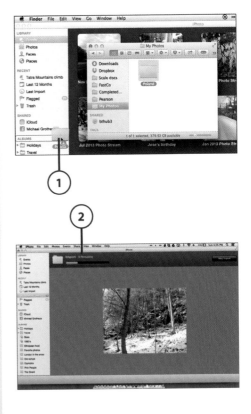

3. When it finishes, you'll see all the photos contained in that folder in their own album. The album is named after the original folder name. You can double-click it to rename it if you want.

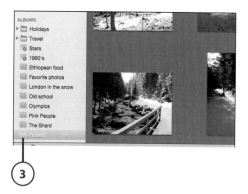

Changing the Contents of Your Regular Albums

After you've created a regular album, it has the same contents in it until you choose to add or remove photos. If you've created an empty album, this means it has no photos in it until you manually move some there. The great thing about regular albums is you can manually add more photos to them any time you want. There are multiple ways to do this—meaning there is no one right way. Find the way that works best for you and stick with that.

Add Photos to an Existing Album by Drag and Drop

1. Select individual photos one at a time and drag and drop them onto the album, select multiple photos by dragging a box around the photos you want in the album, or select nonsequential photos by Command-clicking them. You can also Shift-click to select a sequential range of photos.

2. Drag the selected photos onto an existing album. When the selected photos are over the album, you'll be able to see how many will be added to the album via a red badge with a number in it displayed at the bottom of the dragged photos thumbnail.

Adding Events to Albums

You can also drag an entire event—or multiple events—into an album.

Add Photos to an Existing Album with the Add To Button

1. Select the photo, photos, or events you want to create an album from.

2. Click the Add To button.

3. Select Album from the pop-up menu.

4. Scroll through your list of existing albums in the expanded pop-up and click the desired album.

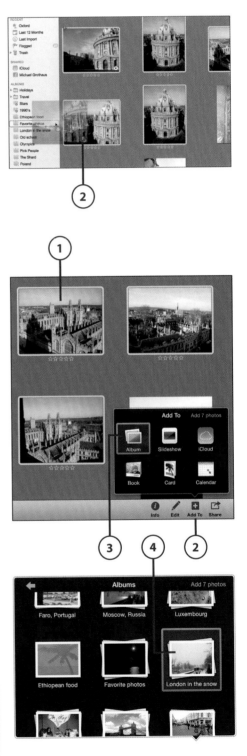

Removing Photos from Albums and Deleting Entire Albums

Just because you've created an album in the past doesn't mean you are going to want to keep it the same forever. You might have created an album to quickly sort out photos for a project and now no longer need them grouped together, so you want to delete the entire album. Or you may find you like an album but want to remove some photos from it.

iPhoto makes either of these steps very simple when dealing with regular albums.

Remove Photos from Regular Albums

1. Select the album from iPhoto's source list.

2. Select the photo or photos you want to remove.

3. Tap the Delete key on your keyboard. Or right-click one of the selected photos and choose Remove from Album from the contextual menu.

4. Click Remove Photos in the confirmation dialog box.

Not Really Gone

Remember, when you remove a photo from an album, you aren't deleting it from your iPhoto Library. It still remains in your iPhoto Library and also in any other albums you have it in.

Delete Entire Regular Albums

1. Select the album from iPhoto's source list that you want to delete.

2. Press the Delete key on your keyboard. You can also right-click the album in the source list, and choose Delete Album from the contextual menu. *Or…*

3. …from iPhoto's menu bar, choose Photos, Delete Album.

4. Click Delete in the confirmation dialog box.

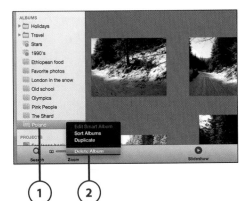

Album's Gone; Photos Aren't

Remember, when you delete an album, you aren't deleting the photos it contains. They still remain in your iPhoto Library and also in any other albums you have them in.

Creating Smart Albums

Now that you know how to create regular albums, you can see how useful they can be. They let you organize your photos in a way events do not—by putting the same photo in more than one location. However, as you can also see, regular albums involve a lot of manual work. To keep your albums updated, you must actively add or remove photos to them. Wouldn't it be great if there were a way to automatically add photos to albums? That's where smart albums come in.

Smart albums enable you to create albums containing photos based on certain parameters, such as rating, Exif information, text or description, date, keywords, and more. The best thing of all is that when you import photos to your iPhoto Library, they are automatically added to any smart albums they match the criteria for.

1. Choose File, New Smart Album.

2. From the Smart Album dialog box that appears, enter the name of the smart album.

3. Choose a filter from the first drop-down menu. A filter is a specific criterion that must be matched for iPhoto to judge whether the particular photo fits into one of your smart albums. A filter can be a keyword, the date the photo was taken, the photo's rating, or even Exif information such as the camera's model or focal length.

4. After you have selected a filter, choose a verb from the verb list. Common verbs in this list are Is, Is Not, and Contains.

5. Enter a requirement in the conditions list. This could be a star rating or a specific keyword.

6. Click the + button to add more criteria.

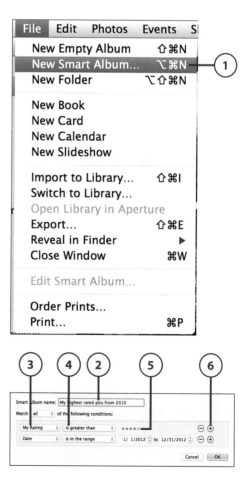

7. Select whether any or all of the multiple criteria must be met.

8. Click OK when you are done.

9. The smart list appears under the Albums header in iPhoto's source list.

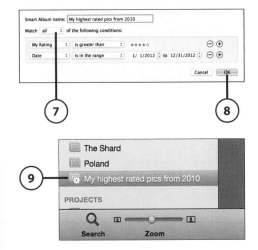

Automatic Photo Management

In this example, the smart album is created and appears in the Albums list in iPhoto's source list after you click OK. All the photos in the iPhoto Library rated as four stars or more from 2010 show up in the album. If you were to reduce a photo's rating in that smart album from four to three stars, the photo would automatically be removed from the smart album because it no longer meets the criteria.

Editing Smart Albums

As with regular albums, iPhoto lets you edit the contents of smart albums. However, instead of adding or deleting photos by drag and drop, to change the contents of a smart album you must edit the album's parameters.

1. Select the smart album in iPhoto's source list.

2. Choose File, Edit Smart Album. *Or...*

3. ...right-click the smart album in the source list and choose Edit Smart Album from the contextual menu.

4. Make changes to the existing criteria, or delete the criteria entirely. You can also add criteria by clicking the + button.

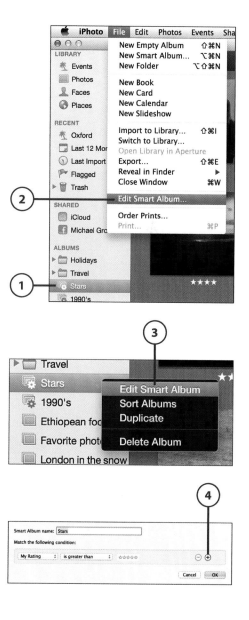

Deleting Smart Albums

As with regular albums, you might find that you no longer need a smart album you've created. No problem. It's easy to delete a smart album.

1. Select the smart album from iPhoto's source list that you want to delete.

2. Press the Delete key on your keyboard. You can also right-click the smart album in the source list and choose Delete Album from the contextual menu. *Or...*

3. ...choose Photos, Delete Album.

4. Click Delete in the confirmation dialog box.

Deleting Albums, Not Photos

Remember, deleting an album, regular or smart, does not delete the photos within that album. The photos are always contained in their event (and therefore the iPhoto Library), and any other albums you have not deleted.

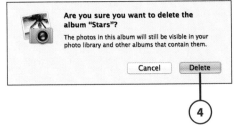

Duplicating Albums

iPhoto enables you to duplicate existing albums with just a few clicks. Why might you want to duplicate an album? Well, if it's a smart album, you might like your search criteria but want to tweak it a little without changing the original smart album. Duplicating the album enables you to work from the original album without having to re-create it from scratch. The same goes for regular albums. Duplicating a regular album makes it easy to create an album with altered content based on photos you've already collected.

1. Select the album in iPhoto's source list.

2. Choose Photos, Duplicate. *Or…*

3. …right-click the album and choose Duplicate from the contextual menu.

4. An exact duplicate of the album is created with a 2 appended to its name.

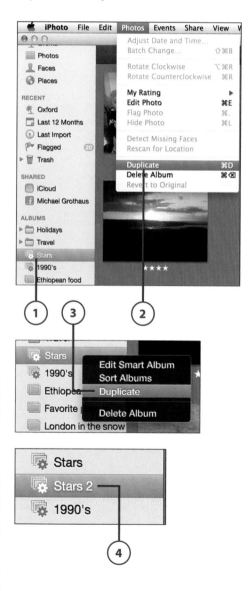

Organizing Albums into Folders

You might love creating both regular and smart albums, but sometimes things can get out of control when you have dozens of albums. When this happens, the things you've created to organize your photos become hard to organize themselves. Luckily, with iPhoto you can organize albums into folders. This enables you to group several albums together for clarity. For example, you can group all your travel albums into one folder and group all your Christmas albums into another.

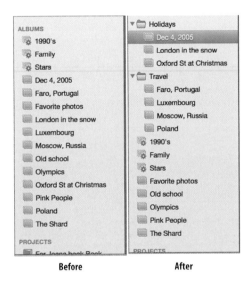

Before After

The "before" picture shows how albums are arranged in iPhoto without any folders. There are smart albums (cogs) and regular albums (no cogs).

In the "after" version, you can see what happens when you create folders. The folders appear in the list and contain whatever smart or regular albums you've dragged into them. Albums within a folder are indented. Any albums that are not sorted into folders show up after the last folder—smart coming before regular. Folders can contain both smart and regular albums.

Create an Empty Album Folder

1. Choose File, New Folder.

2. A new untitled folder appears under the Albums heading. Double-click the folder to rename it.

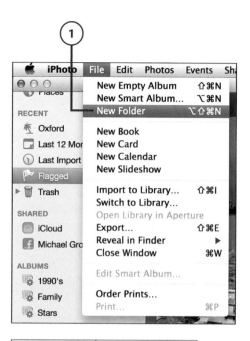

Add Albums to a Folder

After you've created a folder, it's time to add albums to it. The albums you add can be regular, smart, or a combination of both.

1. Select the regular or smart album in iPhoto's source list.

2. Drag it on top of the folder.

Seeing Them All

Selecting a folder displays all the photos in every album in that folder.

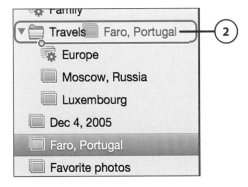

Create a Folder by Joining Two or More Albums

You can bypass the process of creating a new empty folder if you already know the albums you want to group under a single folder.

1. Select the first album.

2. Drag the album onto another album.

3. Both albums appear in a new untitled folder. Click twice on the folder to rename it.

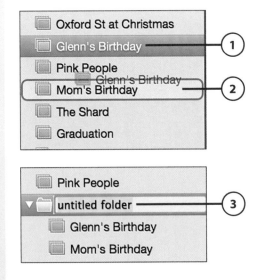

ADDING A FOLDER TO A FOLDER

For the super-organized, or those with just a ton of albums and folders, you can actually nest folders full of albums inside another folder. This could be handy if you organize folders by year, with subfolders being specific events from that year. However, unless you are actively using iPhoto to manage your pictures on a daily basis like this, I don't recommend you nest too many folders inside folders, or things get confusing. You risk soon losing the ability to quickly and easily see where your albums are located. If you do want to nest folders inside one another, simply drag one folder into another.

Remove Albums from a Folder

If you change your mind and no lon-ger want to group a specific album into an existing folder, you can easily remove it.

1. Select the regular or smart album in the folder in iPhoto's source list.

2. Drag the album out of the folder and onto iPhoto's source list.

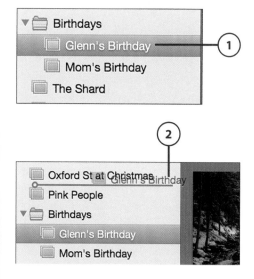

Delete a Folder

If you decide you no longer want a folder, you can delete the entire thing.

1. Select the folder you want to delete.

2. Press the Delete key on your keyboard. You can also right-click the folder and choose Delete Folder from the contextual menu.

3. Click Delete in the confirmation dialog box to delete the folders and albums.

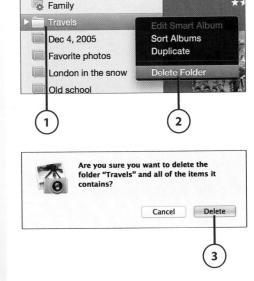

Deleting the Folder but Keeping the Albums

To delete only the folder and not the albums it contains, remove the albums from the folder first. If you delete a folder with no albums, it is removed instantly, and you will not see the delete folder confirmation dialog box.

Sorting Your Albums Alphabetically

After you've created many smart albums and regular albums, it becomes apparent how handy folders can be: They provide an extra way you can keep a tidy iPhoto Library. However, with so many folders and albums, things can still get messy. If that happens, you might want to alphabetize your albums and folders from time to time for easy ordering.

1. Right-click on any folder or album name under the Albums header in iPhoto's source list.

2. Choose Sort Albums from the contextual menu.

3. iPhoto instantly organizes all your folders and albums alphabetically. Note that if the album you right-click is in a folder, only the albums in that folder are sorted. To sort all the albums—no matter if they are in a folder or not—be sure to select a folder or album name directly under the Albums header.

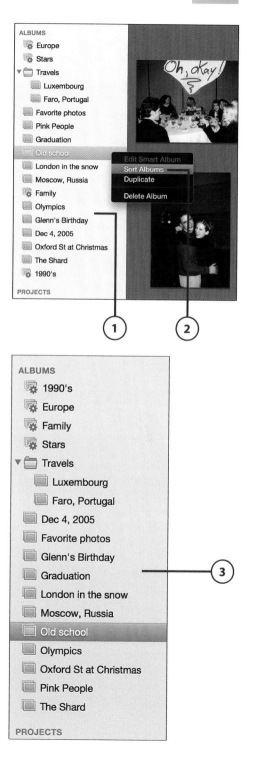

Name of
album or event
the photo is in

Previous/Next
Photo button

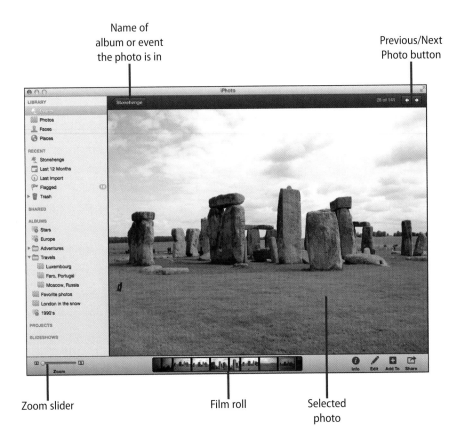

Zoom slider

Film roll

Selected
photo

In this chapter, you learn how to view the photos you've taken.

→ Working with photo thumbnails
→ Using the film roll
→ Sorting your photos

Viewing Your Photos

Although iPhoto lets you organize your photos in a variety of ways, from albums and events to Faces and Places, the end goal of that organization is that you can actually view individual pictures quickly and easily. For this, iPhoto has a few, but important, tools to help you view that amazing pic.

Working with Photo Thumbnails

A thumbnail is a miniature representation of your larger photograph. While looking inside an album, event, or your entire photo library, a thumbnail enables you to see multiple photos at once, which helps you find the one you are looking for faster.

Thumbnails

Adjust Thumbnail Size

By default, a thumbnail is of a medium size in iPhoto. However, you can manually adjust the size of thumbnails to make them larger and easier to view, or smaller, which allows you to see more images at once.

1. Select an event, album, or the Photos header in iPhoto's source list so your photographs are displayed as thumbnails in the body of iPhoto.

2. In the iPhoto toolbar, drag the Zoom slider left or right. Dragging it to the left shrinks the thumbnail size; dragging it to the right increases the thumbnail size.

Quickly Rotating Photos

When viewing thumbnails, if you notice a photo in your album or event is rotated the wrong way—for example, it's horizontal when it should be vertical—you can quickly rotate it by right-clicking the photo and then selecting Rotate from the contextual menu.

View an Individual Photo

After you've found the photo you want to view in your thumbnails, bringing it full screen in iPhoto's main viewing window is easy.

1. Press the spacebar on your keyboard to see it full screen, or double-click the photo.

2. The photo expands until it fills the entire frame of iPhoto's viewing window.

Working with the Film Roll

When you're viewing a photo full screen, the toolbar at the bottom of iPhoto's window changes to display a film roll. This film roll shows thumbnails of all the other photos in the selected album or event. It's handy for quickly skimming through the other pictures associated with the one you are viewing.

1. Move your mouse over the film roll. The film roll enlarges on your screen.

2. Scroll through the film roll using your mouse's cursor until you find a photo you want to view.

3. Click the photo you want to view, and it displays in iPhoto's window, replacing the previous one.

Sorting the Order of Your Photos

iPhoto enables you to sort the display order for your photos and events. By default, iPhoto shows you your events, and your photos inside albums and events, from oldest to newest. However, you can change the setting so you can sort the display order of your photos and events to better fit your workflow.

Sort Events

1. Select events in iPhoto's source list.

2. Choose View, Sort Events.

3. Choose one of the following ways to sort events:

 - **By Date:** Arranges events by the date on which they were taken, from oldest to newest

 - **By Title:** Arranges events alphabetically by their titles

 - **Manually:** Lets you drag events into any order you want

4. If you sort your events by Title or Date, you can reverse the order of the sort by choosing View, Sort Events and then choosing Ascending or Descending.

5. Click Reset Manual Sort to revert to iPhoto's manual sort order.

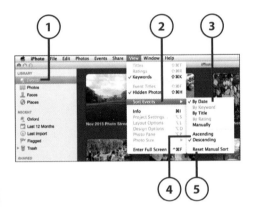

Sort Photos

1. Select the album or double-click the event containing the photographs you want to sort.

2. Choose View, Sort Photos.

3. Choose to sort photos by one of the following options:

 - **By Date:** Arranges events by the date on which they were taken, from oldest to newest.

 - **By Title:** Arranges events alphabetically by their titles.

 - **Manually:** Lets you drag events into any order you

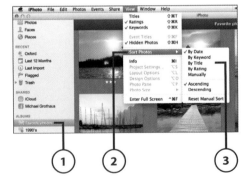

want. This option is not avail-
able for photos inside events
or smart albums.

- **By Rating:** Sorts photos from
 lowest (no stars) to highest
 (five stars) rating.

4. If you sort your events by Title,
 Date, or Rating, you can can
 reverse the order of the sort by
 choosing View, Sort Photos and
 then choosing Ascending or
 Descending.

5. Click Reset Manual Sort to revert
 to iPhoto's manual sort order.

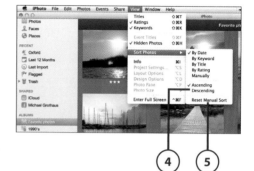

Auto Manual Sort

Be aware that whatever your sort
setting, if you drag a photo in an
album to a new position, iPhoto
automatically switches to manual
sorting again.

The Faces
corkboard

Add your friends
and family

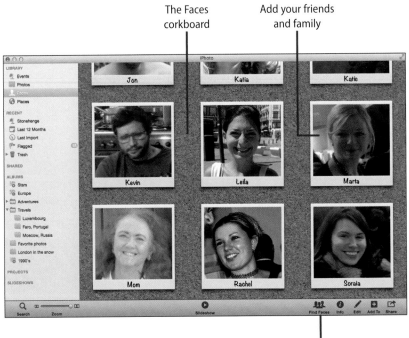

Find more
faces

In this chapter, you learn how to use iPhoto's built-in facial recognition software to organize your photos by the people in them. Apple calls this feature Faces—and it's one of iPhoto's coolest tools.

→ Creating Faces collections
→ Navigating the Faces corkboard
→ Naming and matching faces
→ Using Faces with Facebook

Organizing Your Photos: Faces

Faces is one of those features of iPhoto that makes you take a step back and go "Wow!" With Faces, iPhoto uses facial recognition technology built in to the software to identify and group individuals into collections of photos. This way you can easily see all pictures of your child, spouse, or a particular friend in a single location—the Faces corkboard.

The Faces feature, like events, albums, and smart albums, is just another excellent and fun way iPhoto lets you easily sort, navigate, and organize your photos into manageable collections. It also shows you the power of iPhoto. Who would have ever thought that our computers would be able to pick out and identify our friends and family in our photographs with very little effort on our part?

Creating Faces Collections

When you select Faces for the first time, you see the Find Faces screen. The Find Faces screen displays thumbnails of people iPhoto thinks could be important to you. It's then up to you to name a person in the thumbnail or reject them. Naming a face adds that face to the Faces corkboard.

Create a Faces Collection

1. Select Faces in iPhoto's source list. By default, iPhoto will have already scanned the photos in your iPhoto Library to pick out and identify faces of people who appear in your photographs.

2. Choose to name or hide any of the faces shown to you.

3. Click the Show More Faces button to see more faces.

4. Click the Continue to Faces button to go to existing Faces collections.

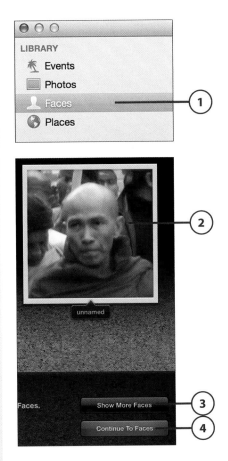

Name a Face for the First Time

If the Find Faces screen shows you a face that is important to you, you'll want to name it so that person is added to your Faces corkboard.

1. Click Unnamed in the naming field below a face.

2. Enter the name of the person in the photo. You can enter just a first name, first and last names, or even a nickname. As you begin entering a person's name, iPhoto displays the names of people who match the text you've entered so far from your Contacts, already-added faces, or Facebook friends (if you've signed in to your Facebook account in iPhoto). Click any of the selected results from the name pop-up menu to apply that name to the face, or continue entering a different name. After you have entered a name, press Return.

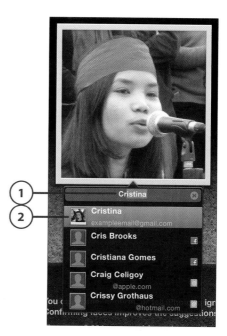

Ignore a Face

Sometimes you might not want to name a face that iPhoto has detected. Perhaps it's just a random person in a crowd or someone you don't like very much (like your pesky boss). iPhoto allows you to ignore these faces.

1. Move your mouse over the face's thumbnail.

2. Click the white *x* inside the black circle at the upper-left corner of the thumbnail. The face thumbnail fades, signifying that iPhoto knows to ignore it in the future. If you have mistakenly told iPhoto to ignore a face you want to track, move your mouse over the thumbnail again, and click the *x* a second time.

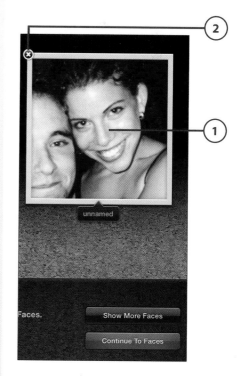

3. After you have completed naming or ignoring the faces on the screen, you can click the Show More Faces button to see more faces. iPhoto displays another series of faces that you can choose to name or ignore.

4. Click the Continue to Faces button when you're done naming faces. You see the Faces corkboard where your selected faces are displayed.

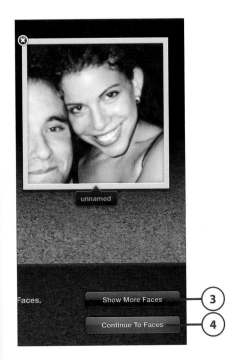

It's Not All Good

HEY, THAT'S NOT A PERSON

iPhoto's facial recognition software is so good it can detect the faces in inanimate objects. For example, iPhoto often asks you to name faces that appear in photographs hanging on a wall behind the person in the actual photograph. It also registers faces on statues and in paintings. This can actually get quite annoying, but the technology isn't sophisticated enough to enable iPhoto to distinguish between real people and things that only look like real people.

The Faces Corkboard

The Faces corkboard displays collections of photos that your family and friends appear in. After the first time you name people in Faces, you automatically see the Faces corkboard when you select Faces from iPhoto's source list.

A thumbnail photograph that looks like an old Polaroid picture represents each Faces collection. Below a Faces collection is the name of the person written in Felt Marker font. When you are on the corkboard, double-click any Faces collection to see all the photos that iPhoto has recognized that person in.

Set Faces Key Photos

As you skim your mouse across each Faces collection, you see a close-up, or headshot, of the individual's face in every photo he or she appears in that iPhoto has recognized. You can use any headshot as the key photo for that particular Faces collection. The key photo is the image that appears in the Polaroid-type border.

1. Skim your cursor left to right over the desired Faces collection.

2. When you find the photo that you want to represent the person in the collection, press the spacebar on your keyboard, or right-click and choose Make Key Photo from the contextual menu.

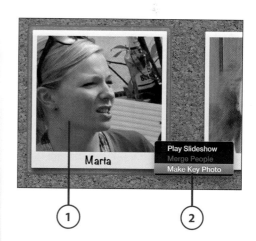

The Faces Information Pane

As with events and individual photos, you can click the Info button in the toolbar while you're on the Faces corkboard so that you can see more information about the selected Faces collection.

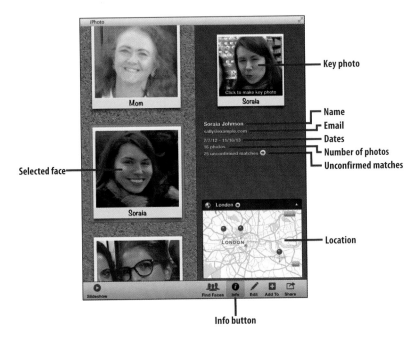

- **Key photo:** This is the thumbnail that represents the person for the Faces collection. You can change the key photo in the Information Pane by running your mouse across it and clicking when you see the photo you'd like to set. Changing the key photo here also changes the key photo on the corkboard.

- **Name:** In this field, you can enter the full name of the person in the Faces collection. This is handy when you might have the collection name displayed on the corkboard as "Mom" or a nickname like "Kaboom" but you want to enter the person's actual name to use for searches. You can also change the name of the person at any time by double-clicking the existing name under the Polaroid photo and entering a new one.

- **Email address:** In this field, you can enter the email address for the person in the Faces collection. At first, this feature might seem rather random, but it actually comes in handy when you start using the integrated Facebook features of iPhoto. If you have an email address

associated with a face, iPhoto uses that information to work with Facebook in accurately identifying Facebook friends in your photos when you upload them.

- **Dates:** This tells you the range of dates in which the photos in the collection were taken. If you have baby photos of your grandpa, this date range could be decades.

- **Number of photos:** This is the number of photos of the person in the Faces collection.

- **Unconfirmed matches:** This tells you the number of photos iPhoto thinks the selected individual might be in. Clicking the arrow takes you to the photo confirmation screen.

- **Location:** This area displays a map of the various locations of the photos the person appears in.

Viewing a Faces Collection

Sorting your photos into Faces collections is actually kind of fun, but the real power of Faces comes when you're ready to view your pictures. A Faces collection acts just like a smart album for the most part, with the exception that the Faces "album" only contains photographs of the same person and cannot have any other criteria applied to it.

1. Double-click the Faces collection thumbnail of the person you want to view.

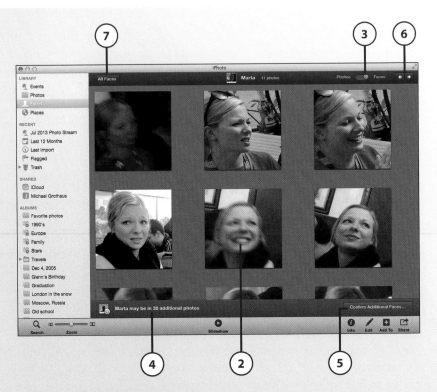

2. All the photos that iPhoto has recognized as a particular individual appear. By default, you'll see only the headshots of the selected person.

3. To view the entire photo, click the Photos/Faces slider in the upper-right corner. All the headshots of the person change to full photographs.

4. Note the alert that the person in the Faces collection you are viewing may be in additional photos.

5. Click the Confirm Additional Faces button to confirm the additional photos now.

6. To go to the previous or next Faces collection, click the Back or Forward button.

7. To return to the Faces corkboard, click the All Faces button.

Photos in Multiple Faces Collections

Because many photos have more than one person in them, the same photo often appears in more than one Faces collection. However, although multiple people can be named in each photo—and thus that photo can appear in multiple Faces collections—an individual's face in a single photo cannot be named more than once.

Confirming or Rejecting Suggested Matches in a Faces Collection

Every time you import photos to your library, iPhoto automatically scans them to detect any known or unknown faces. When iPhoto thinks it might have a match for an existing person in your Faces collection, it displays a notification in two locations.

1. When a face is selected on the corkboard and the Information Pane is open, you see an Unconfirmed Matches note. Click the arrow to enter the Faces confirmation screen. Or...

2. ...when you double-click to view the photos in a Faces collection, you see an Additional Photos note in the bar at the bottom of the screen. In the example, iPhoto thinks Joana might be in 17 additional photographs. Click the Confirm Additional Faces button to enter the Faces confirmation screen.

3. You see the existing matched photos with your selected person, followed by photos that iPhoto thinks the person may be in. These unconfirmed Faces photos all have a black Click to Confirm bar running along the bottom.

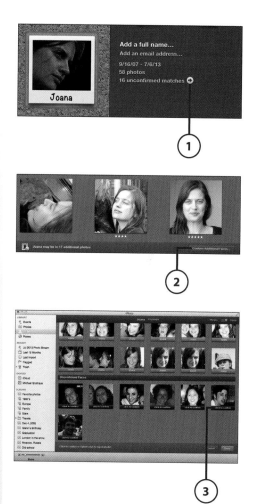

Confirm a Faces Match

1. Click an unconfirmed photo.

2. The black Click to Confirm bar changes to green, and the person's name appears in it.

3. Click Done.

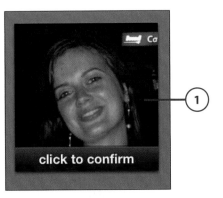

It Pays to Confirm

Confirmed faces become part of a person's Faces collection. Confirming faces increases iPhoto's accuracy at predicting who appears in your photos, so it's a good idea to check frequently to see whether iPhoto has any Faces suggestions for you.

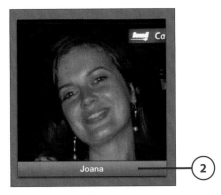

Reject a Faces Match

If the person in the unconfirmed photo *is not a match* for the person in the Faces collection, you should let iPhoto know.

1. Click an unconfirmed photo twice so the black bar changes from black to green and finally to red. You can also hold down the

Option key on your keyboard and click a photo once to confirm it is not a match. The red bar reads "Not [name]."

2. Click Done.

Confirming Multiple Matches

You can confirm or deny multiple matches at the same time by selecting a group of unconfirmed photos; just drag the mouse around them and then click any of the selected photos once to confirm they are a match or twice to confirm they are not a match. Click the Done button to finalize your selection.

Correcting Mistaken Matches

If you've made a mistake, you can always go back and click the green confirmed bar for any photo to tell iPhoto that the photo is not a match. The photo will be removed from that Faces collection.

Rescanning Your Photo Library for Faces

If you know the person in your selected Faces collection is in other photographs despite them not showing up in the Additional Faces confirmation screen, you can tell iPhoto to rescan all the photos in your library.

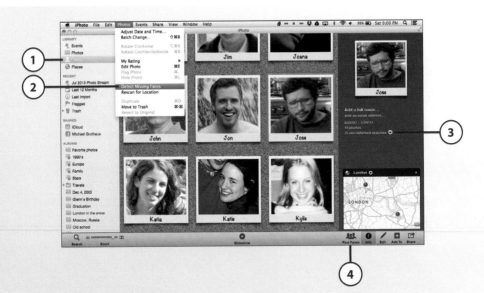

1. Select Faces in the source list.

2. Choose Photos, Detect Missing Faces.

3. Return to your Faces collection and see whether iPhoto has found any other unconfirmed matches for your existing Faces collections. *Or ...*

4. ...click the Find Faces button in the toolbar, which takes you to the Find Faces screen again, and see whether iPhoto has picked up any new faces in your photo library.

Increased False-Positives

During a rescan, iPhoto rescans your library with less-stringent criteria than in the original scan. This can result in more false positives for the selected individual, however.

Naming Faces and Adding Missing Faces Manually

Sometimes iPhoto won't recognize that certain people who already have a Faces collection are in other photos. This can be because of the angle of the person's face in the photo, or perhaps there is a large age gap in the person from one photo to the next (like if you have a picture of your grandma when she was 10 and another when she was 80).

Other times, iPhoto might not even detect a face in a photo. This is primarily because of the angle of the face in the photo or the quality of the image.

In either case, you can manually add a person to an existing Faces collection or tell iPhoto that it is not detecting a face in a photograph.

Name a Person with an Existing Detected Face

You can name a person manually if iPhoto doesn't recognize a person you know is in a photograph.

1. Select the photo that contains the person in your iPhoto Library.

2. Click the Info button in the toolbar.

3. Move the mouse over the unnamed person's face so a box appears around it.

4. Click the Unnamed pop-up menu under the person's face and enter the name of the person. Doing this tells iPhoto it is indeed the same person as the one in the Faces collection.

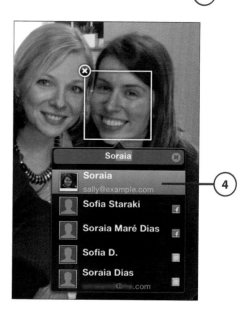

Creating a Faces Collection from Within a Photo

You can also use the previous steps to create Faces collections when viewing a photo instead of using the Find Faces feature. This means you can jump right in to naming your favorite people instead of relying on iPhoto to pick out their faces.

Add a Face Manually

Sometimes for whatever reason, iPhoto's face detection software fails to recognize a perfectly obvious face. If this happens, you can manually tell iPhoto the face exists and name the person in it.

1. Select the photo that contains the face you want to recognize.

2. Click the Info button in the toolbar.

3. Click the Add a Face button under the Faces header.

4. A new Face field appears over the selected photo.

5. Drag and resize the Face field to the correct location on the unrecognized face.

6. Click the Click to Name pop-up menu and add the name of the person. If it is of an existing person in a Faces collection, the photo is added to that collection. If it is a new person, a new Faces collection is added to the Faces corkboard.

Helping Faces Help You

When adding faces manually, it is a good idea to find a photo of the person in profile, as well as head-on, and name both. Naming both profile shots of people and head-on shots gives iPhoto a better chance of finding more photos of them no matter what their orientation in the photograph.

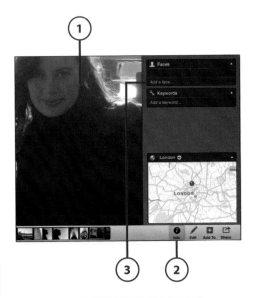

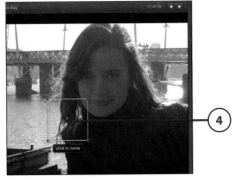

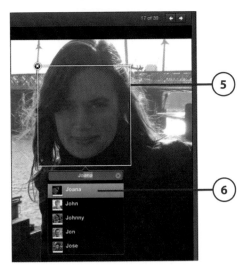

Removing People from Faces

iPhoto enables you to remove a Faces collection from your corkboard. This is especially handy if you want to stop tracking which photos a certain person appears in—say, your ex—or if you've just decided you don't need to create a Faces collection for every single person in your iPhoto Library, like the hotdog vendor on 53rd Street.

1. Click Faces in iPhoto's source list.

2. Select the Faces collection you want to remove so it is highlighted in a blue border.

3. Hold the Command key and then press Delete.

4. Click the Delete Face button. The person's collection is removed from the corkboard, and her name is removed from any photo she appears in. The photos in which she appears still remain in your iPhoto Library.

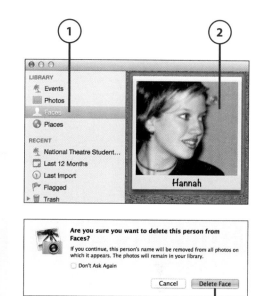

Using Faces with Facebook

It seems everyone these days is using Facebook, and of course one of the big features of Facebook is photo sharing. With iPhoto, Apple has made it easy for you to post photos from your iPhoto Library directly to your Facebook wall. Read Chapter 13, "Sharing Your Photos Digitally," for information about Facebook sharing, including setting up iPhoto for use with your Facebook account. This section briefly explains how Faces works with Facebook.

Just as iPhoto lets you add names to people in photographs in your iPhoto Library, Facebook lets you add names to people in photographs that you post on its site. When you add a name to a person in a Facebook.com photo, Facebook calls it *tagging*. Naming faces in iPhoto works hand in hand with tagging people in Facebook photos.

Specifically, when you upload a photo to Facebook through iPhoto's sharing features, any names you have applied to people in your photos are cross-checked with your Facebook friends. This is done by checking the email address associated with your Faces collections. If the email address assigned to a Faces collection matches the email address a friend uses to log in to his Facebook account, Facebook knows to apply a tag of that person to the photo after it is posted.

In iPhoto **On Facebook**

The image of Abbey on the left was named using Faces in iPhoto. When that image was uploaded to Facebook (right) via iPhoto, Facebook knew to tag Abbey in it automatically even though she uses her full name—Abigail—on Facebook.

So, if you've named a photo of a person in iPhoto, there's no need to tag that person on Facebook.com if you've uploaded it through iPhoto's built-in Facebook sharing feature. Pretty cool, huh?

View photos by
geographic locale

Switch between
map views

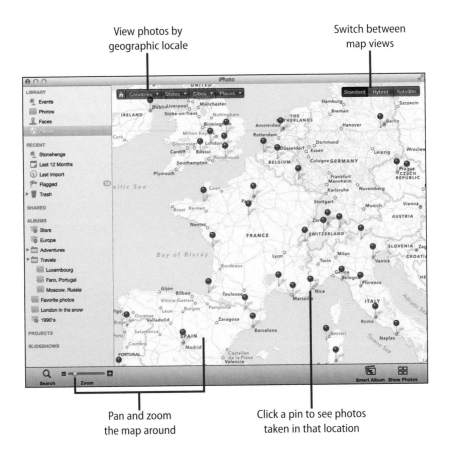

Pan and zoom
the map around

Click a pin to see photos
taken in that location

In this chapter, you learn how to navigate the Places map, which helps you easily track your travels, whether global or in your own small corner of the world.

→ Navigating the Places map
→ Viewing photos by location
→ Manually adding locations to photos
→ Managing your Places library

Organizing Your Photos: Places

Places is probably my favorite feature of iPhoto. If you're a travel buff like me, you can see just how cool a feature it is. With Places, you can easily track all the locations where you took your photos on a large, interactive map. Simply select any pin on the map to view all the photos you took in that location and relive your travels.

From automatic geolocation lookup to easy smart album creation to incredible ways to navigate your photos on a global scale, Places is one of the features of iPhoto that quickly becomes most people's favorite. Together with the Events and Faces features, Places completes the trifecta of the novel ways iPhoto enables you to organize and navigate your photos.

What Is Location Data?

Before we get in to exploring the Places map, let's talk about how Places can automatically "know" where your photos were taken by using location data.

Location data consists of bits of information encoded into the photographs you take that help your camera or photo software accurately pinpoint the location of the photo you have taken. When you take a picture, there are two ways your photos can be automatically tagged with location data. The first is by Global Positioning System (GPS), and the second is by using a known Wi-Fi location.

Your camera might have one of these technologies built in to the hardware. For example, most smartphones, like the iPhone, have built-in GPS chips that tag your photos with their location. Some newer standalone digital cameras also have GPS chips built in.

GPS is a way for the device you are using, such as a phone or computer, to know where it is at any given moment. It does this via a built-in chip that receives coded transmissions from a number of satellites high above the Earth. The built-in chip knows where each satellite should be at any particular point in time and can use that data to interpret and calculate its own location with great accuracy. In a camera with GPS capabilities, these coordinates are encoded in the Exif information, or metadata, of each photograph you take. That Exif information is then extracted by iPhoto, which uses it to display your photos' locations on a map.

A second way the device you are using to take pictures can encode location data is by using Wi-Fi location services. If your camera or media player (like an iPod touch) has a Wi-Fi chip built in to it, it might be able to encode approximate location data into your photo's Exif information that can then be used to "guesstimate" the approximate location your photos were taken in. (This capability is available only in some devices.) It does this by using the location of known Wi-Fi hot spots to pinpoint the place your photo was taken. Wi-Fi location services aren't as accurate as dedicated built-in GPS chips, but at least they put your photos in the right ballpark. Keep in mind, however, that Wi-Fi location services are essentially worthless when your device is out of the range of known Wi-Fi hot spots.

If you have an older camera without location data capabilities, you aren't barred from using Places in iPhoto. iPhoto enables you to manually enter locations for your photos so they appear on the Places map.

Set Up iPhoto to Use Your Location Data

Just because your camera tags your photos with location data doesn't mean iPhoto automatically displays your photos on the Places map. You must first make sure you allow iPhoto to access the location data for your photographs.

1. Choose iPhoto, Preferences from iPhoto's menu bar.

2. Click the Advanced tab.

3. Make sure Look Up Places is set to Automatically. If it is set to Never, iPhoto will not read the location data from the Exif information in your photos.

4. Select the Include Location Information for Published Items check box if you want your photo's location published when you share the photo on iCloud, Facebook, or Flickr.

It's Not All Good

WHY DOESN'T THE LOCATION SHOW UP?

Note that iPhoto does not display your photo's location information when you're not connected to the Internet. When iPhoto reads your photos' location data, it fetches information from the Internet to display the correct locations on the Places map. Without an Internet connection, the Places map does not appear in iPhoto.

If you are using iPhoto somewhere without an Internet connection, you will not be able to view your photos using Places.

The Places Map

When you select Places from iPhoto's source list, you are presented with a map that shows a series of red pins on it. Each red pin represents a location where your photos were taken.

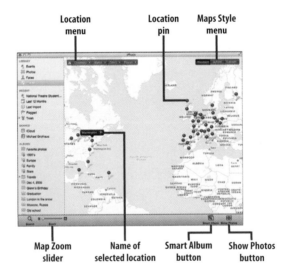

- **Location menu:** Located at the upper left of the map, this menu enables you to jump to specific regions on your map, including Countries, States, Cities, or Places (which means specific locations, such as the Eiffel Tower).

- **Location pin:** Each red pin on the map represents a location where a photo was taken.

- **Name of selected location:** The name of a location pin displays when you select it. By default, it is named after the location it is in.

- **Maps Style menu:** This menu is used to switch between three map views: Standard, Satellite, and Hybrid.

- **Map Zoom slider:** This slider, located below the map, works for the map just the same as it does for zooming in on your photos. Move the slider left or right to zoom out or zoom in on the map.

- **Smart Album button:** This button enables you to create a smart album of the photos from the currently showing pins on the map.

- **Show Photos button:** When clicked, this button displays a contact sheet of all the photos of the current pins in view.

Why Can't I Edit This Map?

Note that the map in Places view is read-only. That means you cannot edit or change locations of photos by dragging the pins around. Everything on the main, large Places map is stationary and fixed. However, the mini-map in the Information Pane of a photo or event is where you edit locations and make changes to your photos. Read more about this mini-map later in the chapter.

Navigating the Places Map Manually

You can manually interact with the Places map in two primary ways: by using the Zoom slider or by using your trackpad or mouse.

1. Use the Zoom slider by moving its tiny ball left or right; as you do so, the map zooms out or in. You can also use the scroll wheel on your mouse to zoom in or out on the map.

2. As you zoom into a location, you may notice more pins appear. This signifies different locations for photos in a more defined area. For example, in the image in step 1 there are five pins representing photo locations in the United Kingdom, but when you zoom in to the UK in the image in step 2, eight pins appear.

Zooming for More Detail

iPhoto limits the number of pins you see when viewing the map in its entirety in order to not clutter the map with thousands of pins. The more you zoom in to one location, the more pins you are likely to see, provided you have photos in multiple locations.

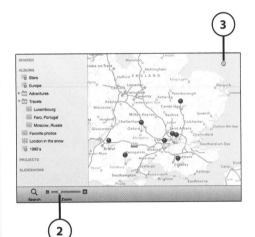

3. After you have zoomed in on a location, you can click and hold your mouse to drag the map around. When you click and hold the mouse button on the map, your cursor icon turns into a hand.

Navigating the Places Map Using the Location Menu

In addition to using the Zoom slider in iPhoto's toolbar, or your mouse or trackpad to navigate the map, you can also use the Location menu to instantly jump to a specific location on the map. The Location menu is the semitransparent bar at the upper left of the map. It consists of a Home button, followed by buttons for Countries, States, Cities, and Places.

1. Click the Home button to view all of your locations on the map. If you've traveled a lot, this might be a very zoomed-out view of the whole planet.

2. Click the Countries button to see a list of all the countries that contain photos taken there. Countries where no photos were taken are not listed. You can click any country in the list to be taken to its location on the map.

Cropped Countries

When selecting a location from the Location menu—a country, for instance—you do not see the entire country on the screen; you see a zoomed-in portion of the country where you have taken photos.

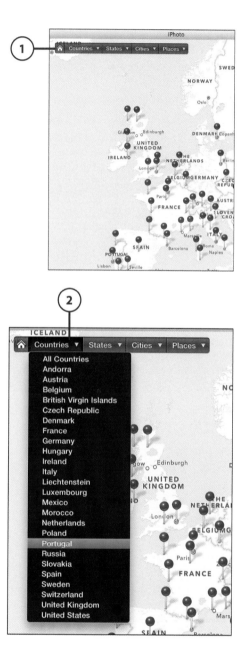

3. Click the States button to see all the states or provinces you've taken photos in. You can click any state or province in the list to be taken to its location on the map.

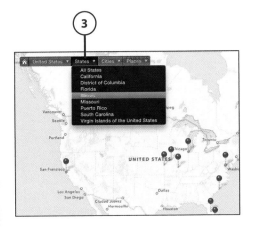

4. Click the Cities button to see all the cities you've taken photos in. You can click any city in the list to be taken to its location on the map.

5. Click the Places button to see all the places you've taken photos in. A "place" in the context of the Places menu is a specific individual location your photos were taken in, including specific addresses, such as your home address, or points of interest, such as the Eiffel Tower. You can click any place in the list to be taken to its location on the map.

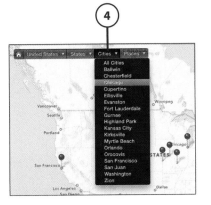

DYNAMIC LOCATIONS

Keep in mind that the Location menu is dynamic. That is, in each subsequent submenu (States, Cities, and Places), you see only locales where you've taken photos and that are located in the previous submenu. So, if you have Portugal selected in the Country menu, you won't see New York City listed under the Cities menu because New York City is not located in Portugal. To see a list of every city you've taken photographs in, click the Home button, then click the Cities button without selecting a country or state.

Switching Between Map Views

iPhoto gives you three options of how to view the map that your photos are presented on in Places. You can switch between these map views using the Map Style menu in the upper-right corner of the map.

1. Click the Standard button. This view shows you the topography of the given map. This view lets you see relief maps of an area's terrain. The Standard view also overlays roads, borders, and labels.

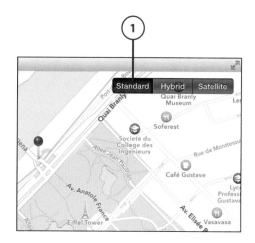

2. Click the Hybrid button. This view combines Standard and Satellite views. You see the map in satellite imagery, but it has labels, roads, and borders overlaid on it.

3. Click the Satellite button. This view shows you the map using satellite imagery. It's perhaps the coolest view because you can zoom in on streets and see little blips of people who were walking on the day the satellite imagery (not your photos) was taken. No labels appear in Satellite view.

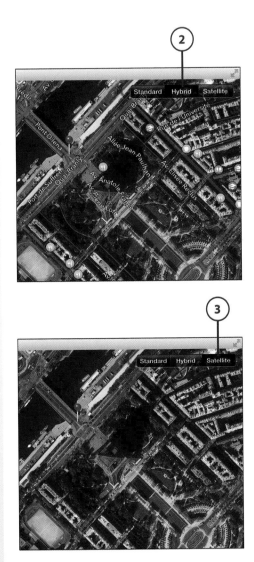

Viewing Your Photos in Places

Places isn't just about viewing pins on a map, of course. Places enables you to easily see all the photos you have taken in a given area. It does this in one of two ways: via its red location pins and via the Show Photos button.

View Photos by Pin

You can easily view all the photos you've taken in a location by using Places' location pins.

1. Click a red pinhead.

2. A black label with the name of the location appears over the pin with an arrow (>) icon on it.

Branching Pins

If you are zoomed out relatively far on the map, a pin may actually contain multiple locations within it. For example, you might see one pin for London at a high zoomed-out level, but the more you zoom in, you might see additional pins branch off from the main London pin. These pins could display hyperlocal areas within London.

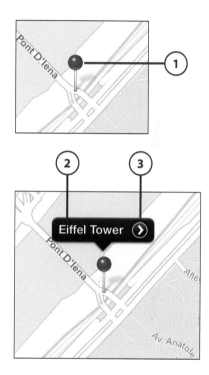

3. Click a label's arrow (>) icon to view all the photos taken in that location. An album that displays all the photos taken within that location opens.

4. Note that if the location is rather broad (for example, London) and in fact contains multiple locations, you see a message at the top of the album that shows how many locations the album contains. For example, in the image for this step, you can see all the photos that are contained in the London pin. Inside that pin are actually 61 locations, which you would see as individual pins if you zoomed in enough on the main

map. However, at the location I chose to display the London pin's photos, it contained 61 separate locations in London.

5. Click the Map button to exit the album and return to the Places map.

View Photos Using the Show Photos Button

A second way to view photos on the map is by clicking the Show Photos button below the map in iPhoto's toolbar. The Show Photos button works a little differently when displaying photos than selecting an individual pin does. If you click the Show Photos button, every photo for every pin viewable on the map is displayed in an album. This is handy when you want to view photos from multiple locations that cannot be combined into one pin by zooming out on the map.

1. Zoom into an area of the map where you want to see all the photos. This area can be as small (a single city) or as large (multiple countries) as you want.

2. Click the Show Photos button in iPhoto's toolbar.

3. You see an album that dislays all the photos taken within the location of the borders of the map you selected.

4. Click the Map button to exit the album and return to the Places map.

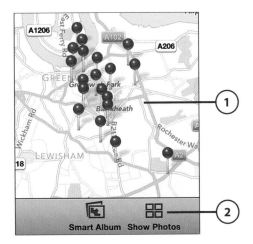

Smart Album Show Photos

Search Photos Based on Location

Besides viewing location photos on a map, you can search for photos taken in a particular location using the Search tool in iPhoto's toolbar.

1. Click the Search button.

2. In the Search field, enter the name of a location (for example, Paris) or a place (for example, Eiffel Tower).

3. The results display in iPhoto's window.

Searching in Predefined Locations

If you've selected a location from the Countries, States, Cities, or Places menus, you can quickly find photos taken in only those locations by clicking the Show Photos button in iPhoto's toolbar.

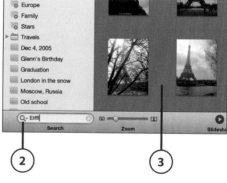

Getting Familiar with the Places Mini-Maps

Don't worry if you don't have a camera with location data capabilities. With iPhoto, you can manually add location data to your photos quickly and easily. Additionally, you can change the location of a photograph that is already assigned a specific place. You make these changes through the Places mini-map.

The Places mini-map is inside the Information Pane. The mini-map is located under the Places header, and it shows the location of the selected photo or the locations of all the photos in a selected event.

Name of location

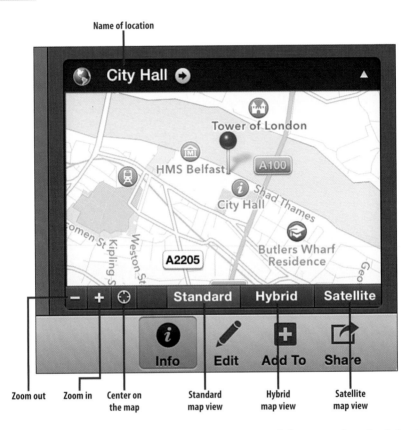

Zoom out Zoom in Center on
the map

Standard
map view

Hybrid
map view

Satellite
map view

Just as with the large Places map, you can switch between Standard, Satellite, and Hybrid views of the mini-map in the Information Pane, zoom in or out of the map, or click the Center button—the one that looks like crosshairs—to center the pins on the map.

Manually Add Locations to Photos

The mini-map is where you can manually add a location to a photo.

1. Select a photo in your library that does not have a location assigned to it. The mini-map in the Information Pane is blank.

2. Click Assign a Place.

3. Start typing the name of the locaton where you know the photo was taken.

4. As you begin to type, iPhoto automatically cross-checks to see whether any other photos in your library have matching locations. iPhoto also displays major locations around the world, such as cities, and points of interest, such as the Eiffel Tower, as location suggestions. Press Return to enter your location.

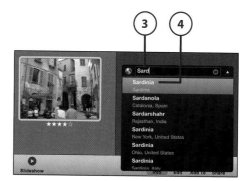

Latitude Before Longitude

You can also enter the exact address—or even the exact coordinates—of a location if you know it. Just be sure to enter latitude before longitude.

5. Optionally, you can select one of the auto-suggested locations iPhoto makes. iPhoto makes these auto-suggestions by searching the Internet to see whether what you are typing matches any major points of interest. If iPhoto finds a matching place, click it to set it as the location.

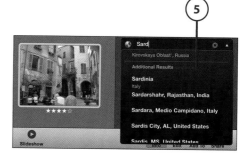

6. iPhoto displays a map with a pin representing the photo's newly set location.

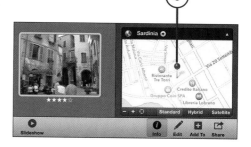

MANUALLY ADDING LOCATIONS TO MULTIPLE PHOTOS

If adding locations to your photos seems tedious, you can make it easier by selecting multiple photos you know were taken in the same location—be it a particular house or just the same city—and then using the steps from the "Manually Add Locations to Photos" section. You can also assign a location to an event. When you do, all the photos in the event are tagged with that location. You can then change an individual photo's location inside that event without affecting the other photos.

Manually Move a Pin

Sometimes when you manually set a fairly wide-ranging area as a location, such as "Lake Geneva," you might want to hone in on the exact location you took the photograph, such as a specific cove on the edge of the lake. In this case, your only option is to manually move the photo's location pin to the exact spot you want.

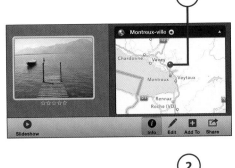

1. Select the pin on the mini-map. The pin jumps in the air, signifying it's ready to be moved.

2. Drag the pin to its proper location. If you need a more detailed view of the map, you can use the plus and minus buttons on the map to zoom in or out to find your new location.

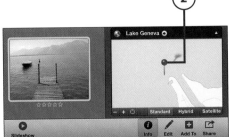

3. Drop the pin in its new location.

4. In the pin's label, click the check mark button to accept the name for the given location.

5. Click the X button to reject the pin's new location. The pin moves to its old location.

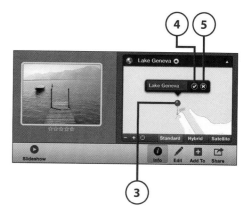

Add Personalized Names to Your Locations

iPhoto lets you add personalized names to locations. So, instead of marking a location as "123 Main Street," you can call it "Mom's House." When you add a personalized name to a location, all photos with that location are updated to reflect the new name.

1. Select the pin on the mini-map that has the location you want to personalize.

2. Enter a nickname for the location.

3. Click the check mark to change the current name to the new one you entered, or click the X to revert to the original name.

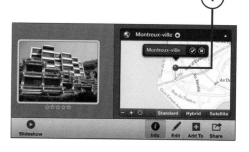

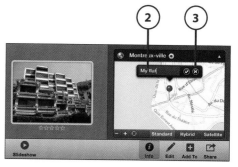

Copy and Paste Location Information

If you've already set an exact location of a photo that you want to use as the exact location of other photos, iPhoto lets you easily copy and paste location information without using Places or Maps at all.

1. Select a photo that already has the desired location information.

2. Select Edit, Copy.

3. Select the photo or photos that you want to apply the previous location to.

4. Select Edit, Paste Location. The location is added to the selected photos.

Removing and Restoring a Photo's Location

You can remove locations from the Places map. Keep in mind that removing a location does not delete the original location data from the photo's Exif information. The photo's location data will always be encoded in its Exif data. *Removing* a location in iPhoto simply removes it from the Places map.

Remove a Location

1. Select the photos or events that include location information.

2. Click the Info button.

3. Click the Places header in the Information Pane.

4. Select the location's name. If there's more than one location, such as for an entire event, the name says "Multiple Locations."

5. Click the *X* to the right of the name. The location name disappears, and the location is removed from the photo or event.

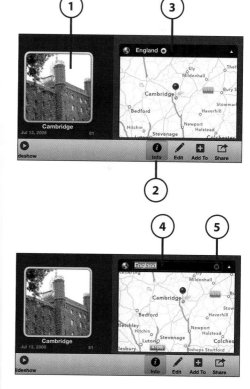

Restore a Location

You can always restore the location to your photos. This is possible because, as mentioned, iPhoto *always* keeps the photo's original location data intact in its Exif information.

1. Select the photo to which you want to restore the location.

2. Select Photos, Rescan for Location. The original location is added back to the photo, which is now viewable in iPhoto again.

Managing Places

iPhoto gives you an easy way to manage all your Places locations in, well, one location. You do this through the Manage My Places window. Using Manage My Places, you can quickly see all the personalized places you've added to your photos, rename or delete them, and even fine-tune your locations.

Open Manage My Places

1. Select Window, Manage My Places.

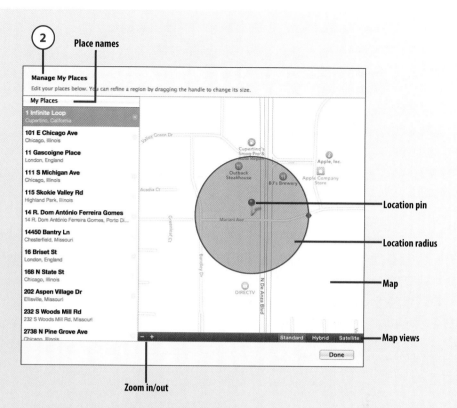

2 **Place names**

Location pin

Location radius

Map

Map views

Zoom in/out

2. The Manage My Places window appears.

Delete a Location

1. Click the minus button in the circle next to the location you want to delete.

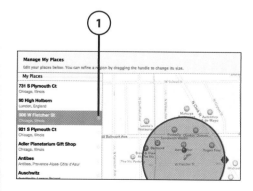

2. Click Delete to confirm that you want to delete the location. The location is removed from the Places map and any photo that contains the location. Your photos will not be deleted.

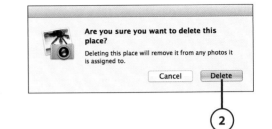

Are you sure you want to delete this place?

Deleting this place will remove it from any photos it is assigned to.

[Cancel] [Delete]

Change a Location's Name

1. Select a place from the list.

2. Double-click its name, and enter a new one. The location's changed name appears in the pop-up list when you are assigning a location to a photo. The changed name only affects the label of the location (for example, "111 S Michigan Ave" becomes "Work") and does not affect the location itself.

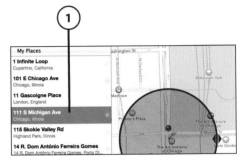

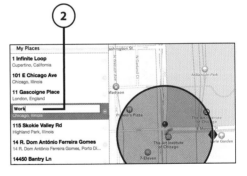

Adjust a Location's Area

You can adjust the location and area of a specific place. This is helpful when you want to fine-tune a pin's exact location, or increase or decrease the overall area of a location.

1. Select the place whose location area you want to change.

2. Click and drag the location pin to your desired location. You can use the map's Zoom button and different views to hone in on an exact location.

3. (Optional) You can click and hold the edges of the purple vicinity circle to signify that a particular location encompasses a given area. This is handy when labeling certain areas, such as parks or large city blocks.

4. Click the Done button to hide the Manage My Places window.

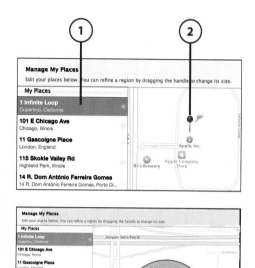

Using Places to Create Smart Albums

Apple has added a handy shortcut button to the bottom of the Places window that enables you to quickly create smart albums based on the locations you are currently viewing in Places. This is advantageous if you want to create a smart album based on a place or places but don't want to go through the manual steps of creating a location-based smart album.

1. Zoom into the region of the map that contains pins for the locations you want to include in the smart album. (Or alternatively use the Countries, States, Cities, or Places menus to limit pins to a certain area.)

2. Click the Smart Album button.

3. A new smart album is created in your Albums list. It's named for the regions it encompasses.

4. Rename the smart album by double-clicking the name and entering a new one.

Future Photos Are Automatically Added by Location

After you have created a smart album for a particular region or location, any photos that you add to your photo library from that point on that match that region's or location's latitude-longitude or location data are automatically added to the smart album.

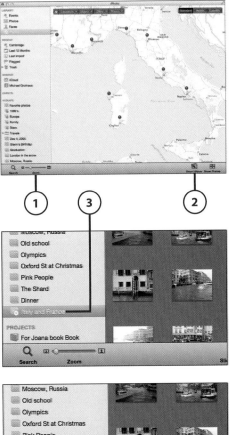

Play around with
photo filters

Choose your
edit mode

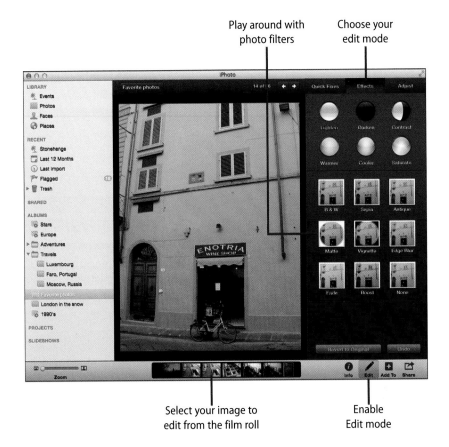

Select your image to
edit from the film roll

Enable
Edit mode

In this chapter, you learn how to edit your photographs using the tools available to you in the editing window. These tools include iPhoto's quick fixes tools and its special effects buttons.

→ Straightening crooked images

→ Cropping photos to fit any size

→ Getting rid of blemishes and reducing red-eye

→ Adding filters to your pictures

Editing Basics

iPhoto is about 60% photo organizer, 20% photo editor, and 20% photo sharer. If you want to be a professional photographer, you aren't going to want to use iPhoto to edit your pics. However, if you are like me and 99% of the population, iPhoto's editing capabilities are more than you'll ever need. As a matter of fact, Apple has made many of iPhoto's editing tools so easy to use that you can apply them with just a few clicks. iPhoto does have some advanced editing tools; however, this chapter looks at the basic tools you'll find yourself using most often. But don't worry; we'll check out the advanced editing tools in Chapter 11, "Advanced Editing Tricks."

The Editing Window

Before you get started with some editing, take a moment to look at the layout of iPhoto in Edit mode. To start, you need to be in Edit mode.

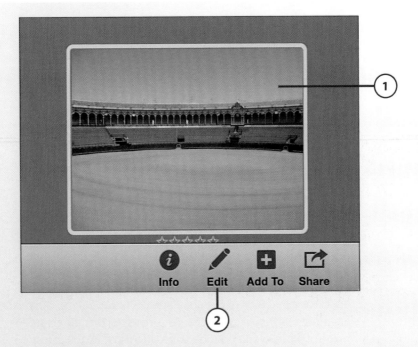

1. Select a photograph from your library that you want to edit.

2. Click the Edit button in the iPhoto toolbar. The Edit button resembles a pencil.

Navigate Edit Mode

iPhoto retains its similar look and feel when you're in Edit mode. On the left side, you have the source list with all its events, faces, places, and albums, and in the middle you have the selected photo you've chosen to display and edit. However, there are some important new features.

Navigation
window

Previous/
next photo

Editing tabs

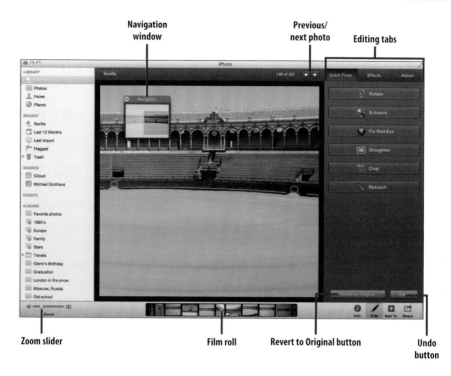

Zoom slider

Film roll

Revert to Original button

Undo
button

- **Film roll:** Use this to navigate the photos in your current album or event. Alternatively, you can use the left/right arrow buttons at the top of your screen to move to the next or previous photo.

- **Editing tabs:** The editing tabs are the meat of the editing window and appear at the upper right of iPhoto's edit screen. The tabs are labeled Quick Fixes, Effects, and Adjust. Each tab, when selected, shows you a different range of editing options. In the figure, Quick Fixes is selected, and you can see its tools, such as the Rotate and Enhance buttons.

- **Zoom slider:** This isn't new; you've seen it before. The Zoom slider simply lets you zoom in to a photograph to see a portion of it in more detail. However, when zooming in to a photograph in Edit mode, using the Zoom slider causes a small navigation window to appear.

- **Navigation window:** The navigation window pops up on your screen whenever you first zoom in to a photograph in Edit mode. The navigation window shows you a thumbnail of the full photograph you are zoomed in to. The zoomed-in portion is displayed in a clear square in the navigation window, and the rest of the photo that isn't visible in iPhoto's main editing window is grayed out.

Navigating with the Navigation Window

When you click and drag the square in the navigation window, the image in iPhoto's editing window pans to match the location of the square. To close the navigation window, click the X in its upper-left corner.

- **Revert to Original button:** iPhoto is a nondestructive editor, so no matter how many edits you make to your photo, iPhoto always keeps a copy of the original image you imported. You can click the Revert to Original button and quickly return your edited photo to its original state, no matter how many edits you have performed.

- **Revert to Previous button:** Note that the Revert to Original button might read Revert to Previous if you've edited the photo during multiple sessions of using iPhoto. Revert to Previous reverts the photo to its last edited state when you exited editing mode. You can keep clicking Revert to Previous until you see the button change to Revert to Original. Click this, and your photo reverts to its original imported state.

- **Undo button:** Unlike the Revert to Original button, which eliminates all your edits, the Undo button only removes the last edit you made in the current editing session. So, if you've fixed red-eye, rotated a photo, and then applied a crop, clicking the Undo button undoes only the crop, not the rotation or the red-eye fix. Click the Undo button again to remove the next edit in the reverse sequence you applied it.

- **Redo button:** Sometimes you might accidentally go a few steps more than you want to when undoing an edit. That's where the Redo button comes in. If you undo too much, simply hold down the Option key on your keyboard, and the Undo button becomes a Redo button. Click it as many times as it takes to redo edits you've undone.

Quick Fixes

If you are using iPhoto to edit your photos, you are likely to be someone who is making simple, fast edits to your favorite pictures. Apple knows this, and that's why it designed iPhoto with a simple three-tab editing layout. The first tab, Quick Fixes, is as simple as they come. This tab enables you to make the six most common edits quickly and efficiently: rotating, enhancing, reducing red-eye, straightening, cropping, and retouching.

Rotate a Photo

Rotating a photo is something almost everyone has done or will need to do. Usually when a photo needs to be rotated, it's because you took it in portrait (vertical) orientation with your camera, but it was imported in the standard landscape (horizontal) orientation.

1. Select the photo you want to rotate.

2. Click the Edit button.

3. Click the Rotate button on the Quick Fixes tab. The selected photo is rotated counterclockwise. The photo rotates 90° each time you click the button.

4. Alternatively, you can rotate a photo clockwise 90° at a time by holding down the Option key on your keyboard and clicking the Rotate button.

Other Ways to Rotate

You don't need to go through these steps each time you want to rotate a photo. There are plenty of other ways to rotate a photo. You can select a photo and then use the keyboard shortcut Command+R. Or you can select a photo and then choose Photos, Rotate Clockwise or Photos, Rotate Counterclockwise from iPhoto's menu bar. You can also rotate a photo via the contextual menu. Right-click a photo to see the menu.

Enhance a Photo

Sometimes you might take a beauti-
fully composed photo in which the
color is off or the photo appears too
light or too dark. When this happens,
there's no need to panic. iPhoto has
a one-click fix for most photos with
ailments such as poor saturation or
contrast; it's called the Enhance but-
ton, and it works almost like magic.

1. Select the photo you want to
 enhance.

2. Click the Edit button.

3. Click the Enhance button on the
 Quick Fixes tab. The selected
 photo is automatically enhanced
 based on saturation levels, con-
 trast, exposure, and more. The
 sample Before and After shots
 show how enhancing a photo can
 really bring out details that would
 normally have been hidden.

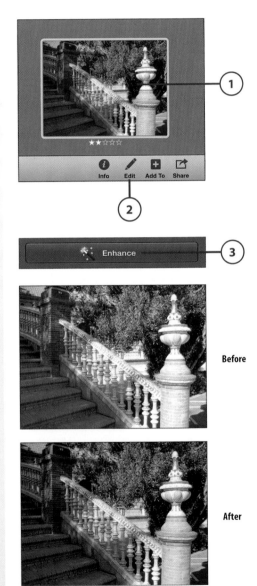

Before

After

Reduce Red-Eye

Ah, red-eye. That red halo that
makes us look like demons in
photographs—it's the scourge of
photographers everywhere. Luckily,
most of the cameras on the market
today offer built-in red-eye reduc-
tion. However, if you still have photos
where your friends look like they're
about to unleash heat vision on some
unsuspecting victim, iPhoto makes it
easy to remove the red-eye effect.

1. Select the photo of a person with
 red-eye.

2. Click the Edit button.

3. Click the Fix Red-Eye button on
 the Quick Fixes tab.

4. If iPhoto detects that there are
 people with red eyes in the
 photograph, it automatically tries
 to remove the red-eye. If this
 doesn't work, uncheck the Auto-
 Fix Red-Eye check box.

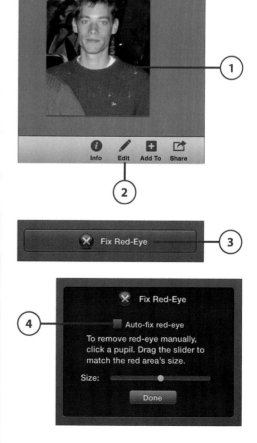

5. To remove the red-eye manually, zoom in to the face of the person with red-eye.

6. Drag the slider in the Fix Red-Eye tool until the size of the crosshairs that appear matches the diameter of the person's eyes. Alternatively, you can also change the crosshair size by pressing the left bracket and right bracket ([and]) on your keyboard.

7. Move the red-eye selector over each eye and click. The red-eye is removed.

8. Click the Done button to exit the Fix Red-Eye menu.

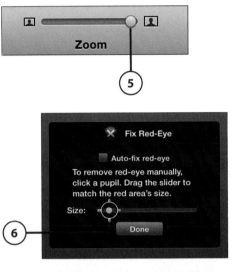

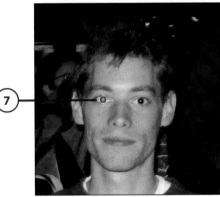

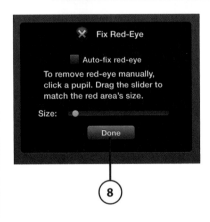

Straighten Crooked Photos

Sometimes you might have a photograph that's a little crooked. Perhaps you weren't holding the camera perfectly steady, or maybe you put it on a ledge and set the timer so you and all your friends could be in the same photograph, but maybe the ledge wasn't exactly level.

iPhoto lets you easily straighten or level photographs by rotating them slightly—up to 45° in either direction. It's a great feature; just don't use it on any photos of the Leaning Tower of Pisa.

1. Select the photo to be straightened.

2. Click the Edit button.

3. Click the Straighten button on the Quick Fixes tab.

4. A drop-down menu appears and yellow grid lines appear over your photograph.

5. Adjust the slider left or right to straighten the photo. Remember, you can straighten it up to 45° in either direction. Use the yellow lines that are overlaid on the photo as a guide to level ground.

6. When you are finished, click the Done button.

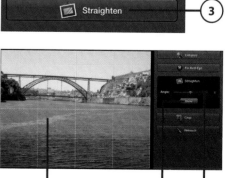

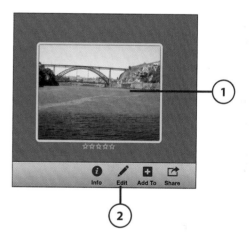

Crop a Photo

There are tons of reasons you might want to crop your photographs. Perhaps you want to just simply cut out something, such as a stray tree branch or a random stranger who walked into the edge of your photograph. Or you might want to crop a photo to bring attention to a certain part, perhaps making it more artistic. Whatever your reason, iPhoto makes cropping photos painless and easy.

1. Select the photo to be cropped.

2. Click the Edit button.

3. Click the Crop button on the Quick Fixes tab.

4. Drag the border of the white crop box in any direction you want. As you do, white grid lines appear in it, which breaks your photo into thirds. These thirds can help you make aesthetically pleasing crops for your photo.

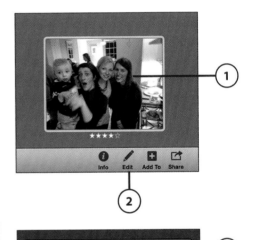

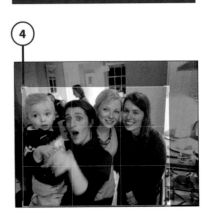

5. (Optional) Check the Constrain check box to constrain your crop to a specific aspect ratio (the size of your photo, such as 4×6 or 8×10) or shape (such as a square or a DVD cover). When you've checked the box, choose the constraint from the drop-down menu. For example, if you choose to constrain the crop to an 8×10, no matter where on the photo you choose to crop, it will be a perfect 8×10 when viewed or printed.

6. (Optional) Click and drag anywhere in the center of the crop box to adjust it to the right spot in the photograph without changing the crop's dimensions. Clicking the Reset button expands the borders of the crop box to the boundaries of the original photograph.

7. Click the Done button to complete the crop. As you can see in the Before and After shot, cropping really helps you tighten a photograph and draw the eye into what's important in the picture.

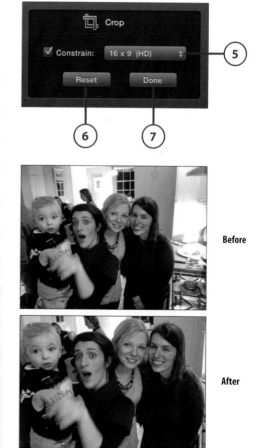

Before

After

THE RULE OF THIRDS

The reason you see three vertical and horizontal lines when you are cropping a photo in iPhoto is because of a tenet in photography called the "rule of thirds." Basically it states that if you divide your shot into an imaginary grid with nine squares by placing three horizontal and three vertical lines "over" the image, and you align the subjects of your shots along one of those lines, preferably the outer ones, it makes for a much more interesting shot.

The rule of thirds is most helpful when you are actually taking photographs with a camera as it helps you compose interesting shots. However, the rule of thirds can be useful to keep in mind while cropping, as you can apply the guideline to turn a boring shot into an interesting shot through editing.

Retouch a Photo

We all wish we had a magic wand that could quickly remove our real-life blemishes, but until science comes up with such a device, at least take solace in knowing that iPhoto has a magic wand of sorts that easily enables you to remove blemishes from your photos. This magic wand is called the Retouch button.

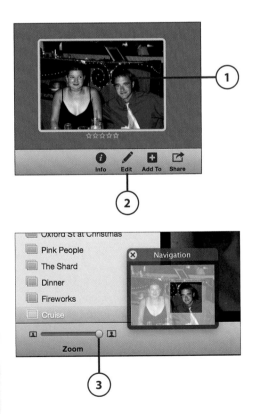

1. Select the photo to be retouched.

2. Click the Edit button.

3. Zoom in on the photograph to the location with the blemish you want to remove. Maybe it's a blemish on the skin or just dust on a photograph that you've scanned into your computer. This example focuses on touching up the mole on the man's chin.

4. Click the Retouch button on the Quick Fixes tab.

5. Use the slider to adjust the brush size of the Retouch tool. Alternatively, you can change the brush size by pressing the left bracket and right bracket ([and]) on your keyboard. The size of the tool should be adjusted to best match the size of the blemish you want to retouch.

6. Move the brush over the mark or blemish you want to remove, and then click the mark with your mouse button or simply drag the cursor across it with the mouse button held down to remove it. If the mark or blemish is small, click it a few times. If that doesn't remove it, drag the brush in short strokes to blend it with its surrounding colors.

7. Click the Done button to save your changes and exit the Retouch menu.

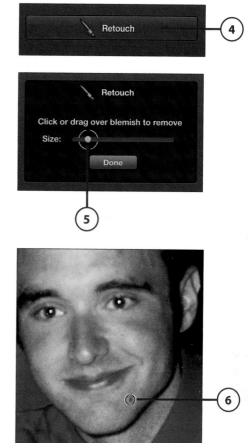

Copying and Pasting Textures

You can get a little more advanced in your retouching abilities in iPhoto by copying pixels from another part of a photo and pasting them onto a mark or blemish. This effectively covers up the spot you want to eliminate. To do this, press the Option key while you click an area that has the texture you want, and then click the area you want to paste that texture on to. Blemish gone!

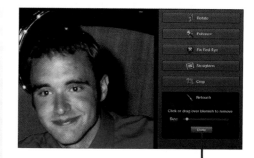

Applying Filters

Thanks to the likes of Instagram, filters are all the rage in photography. Filters (which Apple lamely calls "Special Effects") are simply basic special effects that give your images a different look. They're lots of fun to play around with and great for those of you who want to get a little artsy with your photographs, which is why Apple has included a selection of one-click filters in iPhoto.

1. Click the Edit button in the iPhoto toolbar.

2. Click the Effects tab at the top of the Edit window.

3. Choose the filters you want to add to your photo.

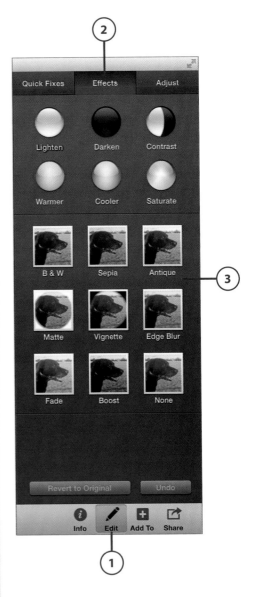

Use the Round Filter Buttons

There are six round filter buttons. The first row of these round filter buttons alters a photo's highlights and shadows. Clicking the Lighten or Darken button adjusts the overall lightness or darkness of your photo one step at a time. Clicking the Contrast button adjusts the contrast, or the difference between light and dark tones, a single step at a time.

The second row of round filter buttons alters a photo's color tint. Clicking the Warmer button deepens the warm colors, such as yellows, reds, and oranges, in your photo. Clicking the Cooler button deepens the cool colors, such as blues, greens, and purples. Clicking the Saturation button adjusts the color intensity of the photo one step at a time.

1. Click one of the round buttons on the Effects tab. You can click any of the round filter buttons as many times as you want. Each time you do, its respective effect is applied to the photo. When you click more than once, there is a cumulative effect. The more you click the Lighten button, for example, the lighter your photo gets.

2. (Optional) To undo the most recently applied effect, you can click the Undo button at the bottom of the Effects tab.

3. (Optional) To completely revert to the original photo, thus removing

all filters you have applied, click the Revert to Original button at the bottom of the Effects tab.

Use the Square Filter Buttons

There are nine square filter (special effects) buttons. These buttons apply a specific filter in increasing cumulative grades—so if you click Sepia multiple times, the photo gets a greater and greater sepia look. You can tell the level of the filter you are on by the labels that appear along their bottoms when they are activated. Here's what the different filters do:

- **B&W:** Changes photo to black and white. This can be only on or off. When B&W is on, you cannot also use Sepia or Antique.

- **Sepia:** Applies a reddish-brown hue to your photo. This can be only on or off. When Sepia is on, you cannot also use B&W or Antique.

- **Antique:** Gives photos an aged appearance, just like the ones you see at your grandparents' house. There are nine levels of Antique. Click the up or down arrows on the labels to move through the levels. If Antique is in use, you cannot also use B&W or Sepia.

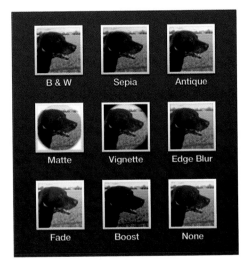

Square filter buttons

- **Matte:** Blurs the edges and corners of a photo in a white oval. There are 24 levels of Matte, each one increasing the diameter of the matte.

- **Vignette:** Darkens the edges and corners of a photo in a black oval. There are 24 levels of Vignette, each one increasing the diameter of the vignette.

- **Edge Blur:** Blurs the edges of a photo like someone has smeared Vaseline on your camera's lens. There are 11 levels of Edge Blur.

- **Fade:** Reduces the color intensity of the photograph as if you've left it outside in the sun for a number of years. There are nine levels of Fade.

- **Boost:** Increases the color intensity of the photograph as if you've printed the same photo directly on top of a copy of it. There are nine levels of Boost.

- **None:** Removes all effects applied to the photo.

Square filter buttons

Apply a Filter

1. From the Effects tab, click one of the square buttons. Some of the square filter buttons have only two modes: on or off. Others have an increasing level of that filter each time you click it.

2. To toggle a filter that only has an on or off mode, click it once to apply the filter (the label below it will say On), and then click it again to remove the filter (the label below changes to Off).

3. For filters with increasing levels of special effects, keep clicking them to increase the special effect. Each time you click, the label below the filter shows you what level it is on.

4. To reduce the level of a multistep filter, click the Back arrow in the label of the filter button.

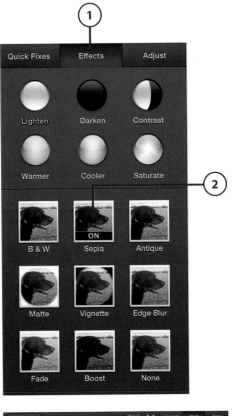

Edge Blur

5. (Optional) To undo the most recently applied filter, click the Undo button at the bottom of the Effects tab.

6. (Optional) To completely revert to the original photo, thus removing all filters you have applied, click the Revert to Original button at the bottom of the Effects tab.

It's Not All Good

FILTER HERE, FILTER THERE

The one thing about filters in iPhoto that is really annoying is that if you apply a filter to any image in iPhoto, that photo gets the filter no matter where it is—even if it's in an existing slideshow, book, card, or calendar. So, if you've made a Christmas card last year that you want to reorder, be sure you check the card again before reordering to make sure you haven't applied a filter to the photo used in it elsewhere. If you have, the card could end up looking very different than last time. A solution to this problem is to duplicate a photo first before applying a filter to it. This way, if that photo has been used in any projects, it won't be affected.

Adjust exposure,
contrast, and saturation

Manipulate tones
with the histogram

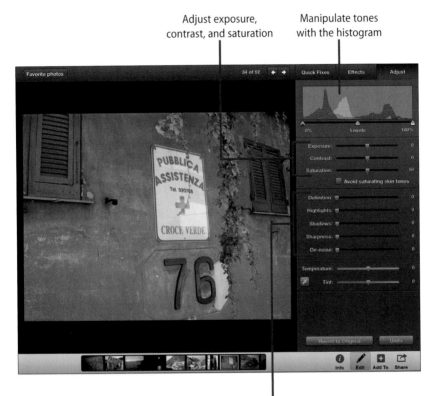

Clean up your images
with advanced controls

In this chapter, you learn how to edit your photographs using the advanced tools available to you in the editing window. These tools include the histogram and all the sliders that let you make granular changes to your photos. You also learn some cool iPhoto tricks that will help you in the editing process.

→ Using the histogram

→ Controlling contrast and highlights

→ Adjusting a photo's color temperature, tint, and color cast

→ Making copy and paste edits

Advanced Editing Tricks

If you want to do some manual editing to your photographs, you'll find all the tools you need on the Adjust tab. The Adjust tab offers the histogram and a multitude of sliders that enable you to tweak your photos in various ways.

Using the Histogram

Just what is a histogram? Entire books can be written on what a histogram is, but for our purposes, this section gives you a very basic description of what a histogram is and shows you how to use it. Don't worry if this seems a little complex. You don't need to understand the histogram to make edits to your photos—just stick with the Quick Fixes and Effects tabs.

A histogram is a graphic representation of the distribution of tones, or light levels, for the three color channels (red, blue, and green) in an image. Black or dark tones are shown in the left of the histogram, mid-tones are shown in the middle, and white or light tones are shown on the right. The histogram graph itself looks like red, blue, and green mountain ranges overlayed on one another.

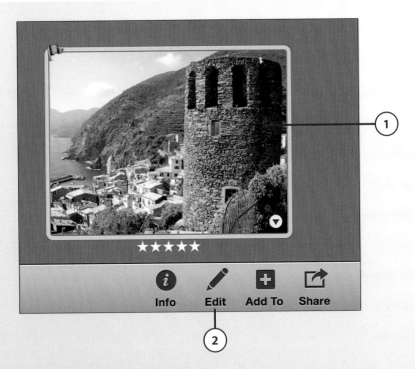

1. Select a photograph from your library for which you want to see the histogram.

2. Click the Edit button in the iPhoto toolbar. The Edit button resembles a pencil.

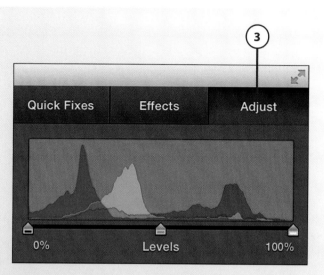

3. Click the Adjust tab at the top of the editing window.

Looking at a histogram can instantly tell you whether your photo has good exposure or whether it is underexposed or overexposed. Underexposed photos appear darker than they should be, and on the histogram chart the mountains are bunched toward the left. Overexposed photos appear lighter, or more "blown-out," than they should be; on the histogram chart, the mountains are bunched toward the right. Remember, though, that under- and overexposed photos aren't necessarily bad. Like many things with photography, "good" exposure is somewhat subjective. Maybe you like your photos darker or lighter. Just because a photo is under- or overexposed doesn't mean you *have* to correct it.

The examples show histograms for a photograph with "good" exposure and also for photographs that are underexposed and overexposed.

Good exposure **Underexposed** **Overexposed**

As you can see in the "good exposure" picture, the red, blue, and green colors are spread fairly evenly throughout the histogram. This signifies that the photo has relatively good exposure. In the middle picture, the photograph was taken at night, and you can see it's quite dark. Without even looking at the photo, you could tell it was underexposed just by checking out its histogram. You can see all the colors in the chart are bunched up toward the left, or black, side. In the third photo (it's a shot of the Golden Gate Bridge against a blue sky), notice that the colors in the chart are bunched up more to the right, or white side, of the histogram. This means the photograph is overexposed.

Adjust the Histogram

Beneath the histogram are three pyramid-shaped markers—one on the left, one in the middle, and one on the right. Below each of those markers is a small bar. The bar on the left is black, the bar in the middle is gray, and the bar on the right is white. These bars signify the black point (tone), mid-tone, or white point (tone) in a photograph. These small triangluar markers with bars are sliders you can adjust to tweak a photo's histogram.

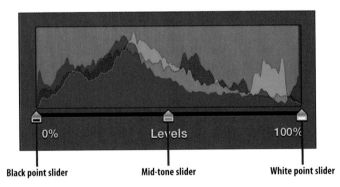

Black point slider Mid-tone slider White point slider

Ideally—and, again, this is all subjective—you want your photos to have a good tone range, with the colors of the chart spread evenly across the histogram. To this end, you can adjust the histogram sliders to clip the ends of the white and black points and adjust the mid-tones—thereby adjusting the photo's light and dark levels—to produce a more balanced photograph.

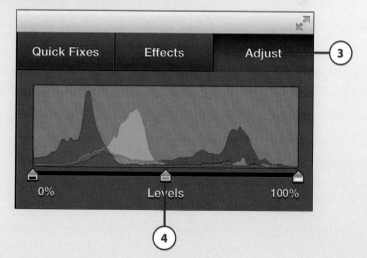

1. Select a photograph from your library for which you want to adjust the histogram.

2. Click the Edit button in the iPhoto toolbar.

3. Click the Adjust tab at the top of the editing window.

4. Drag the black point, mid-tone, or white point sliders underneath the histogram to your desired locations.

When you compare the photographs from earlier in the chapter with the ones shown here, you can see that I left the first one of the "76" wall unchanged because I was happy with the light levels. However, for the second photograph, I dragged the white point slider halfway across the histogram in order to lighten the entire image. I also adjusted the mid-tone slider. I can now see much more detail in the beach, and the overall image is much lighter. For the last photo of the Golden Gate Bridge, I adjusted the black point slider and the mid-tone slider to deepen the colors in the photograph. Note that the red iron and the blue sky are much richer in color now.

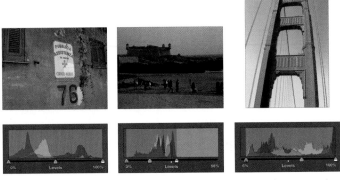

Unchanged good exposure　　**Formerly underexposed**　　**Formerly overexposed**

Remember, using the histogram takes practice. The more you play with the sliders, the better you'll get at manually adjusting the tones in your photographs. But also remember that you don't need to use the histogram at all if you don't want to do so. You can adjust all the tones in your photograph by simply clicking the Enhance button on the Quick Fixes tab. Although manually adjusting the histogram sliders gives you greater control, most iPhoto users will probably find the Enhance button is more than enough for them.

You Can Always Go Back

Keep in mind that you can quickly undo your last edit by clicking the Undo button in the editing window. You can also revert to the original copy of the photograph you are editing—no matter how many edits you've applied—by clicking the Revert to Original button, so don't worry about messing up your photos by playing around with the histogram. You can always undo what you have done.

Adjusting Exposure, Contrast, and Saturation

Below the histogram, the remainder of iPhoto's Adjust editing tools consist of more sliders. iPhoto has these sliders divided into three individual sections, so let's look at them one section at a time.

The first group of sliders are the Exposure, Contrast, and Saturation sliders. There's also a check box regarding skin tones.

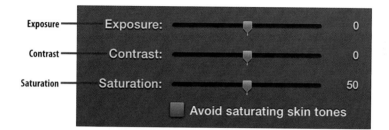

- **Exposure:** Moving this slider adjusts the overall lightness of a photograph. Unlike the sliders directly below the histogram chart, which adjust individual light tones, mid-tones, or dark tones, the Exposure slider adjusts all tones evenly. Drag it to the right of the 0 marker to increase a photo's brightness, or drag it to the left of the 0 marker to decrease its brightness.

- **Contrast:** The contrast of a photo is the amount of difference between the light and dark areas in it. In a high-contrast photo, you see a sharper divide between light and dark. In a low-contrast photo, the divide isn't as jarring.

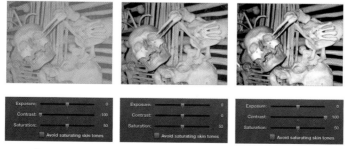

| Low contrast | Neutral contrast | High contrast |

- **Saturation:** Adjusting the Saturation slider changes the color richness, or intensity, of the photograph. The neutral (default) setting is 50. You decrease the intensity of the colors in your photo by dragging the slider left. If you drag the slider to 0, the photo becomes black and white. Conversely, drag the slider to the right to increase the intensity of the colors. If you drag the slider to 100, the colors in your photo look quite nuclear, as if they were radiating light.

It's Not All Good

AVOID SATURATING SKIN TONES

When you check the Avoid Saturating Skin Tones check box, any changes you make to the color intensity of your photograph using the Saturation slider do not affect any skin tones in your photograph. This is a great feature because it allows you to avoid giving the people in your photos horrible orange tans when you increase the saturation of a photo. In the example, the photo on the left has its saturation boosted with the Avoid Saturating Skin Tones check box checked, whereas the photo on the right doesn't. Note the orange skin in the right photo.

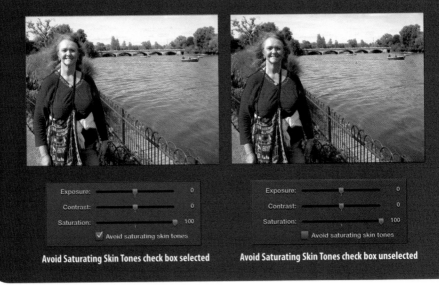

Avoid Saturating Skin Tones check box selected Avoid Saturating Skin Tones check box unselected

Adjust a Photo's Exposure, Contrast, and Saturation

1. Select a photograph from your library that you want to adjust.

2. Click the Edit button in the iPhoto toolbar.

3. Click the Adjust tab.

4. Drag the Exposure, Contrast, and Saturation sliders until you achieve levels you find satisfying.

5. (Optional) Click the Avoid Saturating Skin Tones check box to avoid changing a person's skin tones as you adjust the exposure, contrast, and saturation of a photograph.

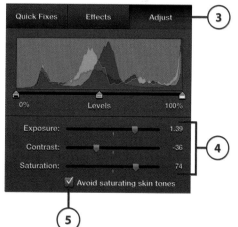

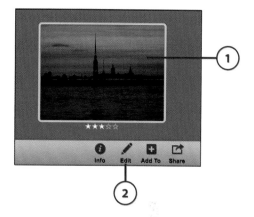

Adjusting Definition, Highlights, Shadows, Sharpness, and Noise

The second group of sliders in the Adjust tab enables you to adjust highlights and shadows in your photographs as well as manipulate the amount of details, grain, and focus in them. After you have adjusted your contrast and exposure, using these adjustment tools can really make your photos pop!

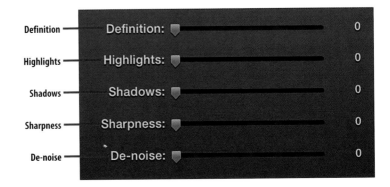

- **Definition:** This slider enables you to bring out the details in a photograph. Just like a person with six-pack abs is called "defined," this slider allows you to chisel away soft lines in your photographs to make impressions stand out.

- **Highlights:** Use this slider to reduce the brightness of highlights in your photo. In other words, it darkens bright areas (such as a bright sky) so you can see more detail in them (such as wisps of clouds).

- **Shadows:** This is the opposite of the Highlights slider. This increases the brightness of shadows in your photo so you can see more detail in a dark area. For example, a person in your photo might be wearing a black shirt. In the photo, the black shirt might look like a solid, almost formless, mass of black. Using the Shadows slider, you can bring out the details in the shirt, such as the ripple in its fabric.

- **Sharpness:** When you edit a digital photo, the adjustments you make to its contrast or exposure can sometimes cause a soft, or blurred, edge to lined objects in your photo. You can use the Sharpness slider to fix the blurred edges so they show up more crisply in photos. (To see the benefit of the Sharpness slider, it helps to be zoomed in on your photograph to something that has defined edges, like a window frame.) Note that you cannot use the Sharpness slider to fix a photo that was taken out of focus.

- **De-noise:** If you've ever taken a photograph outside at night, you've seen noise in your images. Noise is distortion. It's the little blips and specs that show up on your digital photos and appear almost as if they were dust or colored confetti. You can use the De-noise slider to minimize those specs of digital dust.

Don't Be Afraid to Play

The best way to learn to use the tools on the Adjust tab is to play around with them. To see the benefits of making manual adjustments to your photo, see the sample Before and After versions of an adjusted photo.

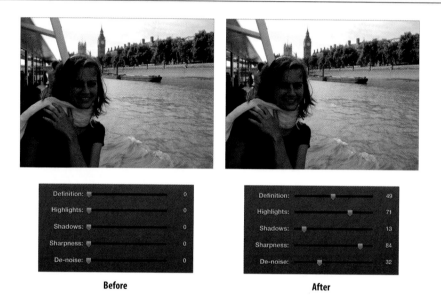

Before **After**

In the photograph I first used the Definition slider to bring out details in the white scarf and waves in the river. I then used the Highlights slider to darken the highlights in the sky, which brought out more clouds. Next, I used the Shadows slider to lighten the shadows in the trees on the riverbank. This allowed me to see more details in their leaves. Then I zoomed in on Big Ben in the background to restore some sharpness to its edges that was lost when adjusting the first three edits. Finally, I slightly adjusted the De-noise slider to remove a few minor artifacts in the image.

Adjust a Photo's Definition, Highlights, Shadows, Sharpness, and Noise

You can try this all out on your own photographs. To adjust a photo's definition, highlights, shadows, sharpness, and noise:

1. Select a photograph from your library for which you want to adjust the definition, highlights, shadows, sharpness, and noise.

2. Click the Edit button.

3. Click the Adjust tab.

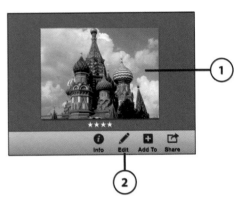

4. Drag the Definition, Highlights, Shadows, Sharpness, and De-noise sliders until you achieve levels you find satisfying.

Adjusting Temperature, Tint, and Color Cast

When you hear temperature, you usually think about the weather outside. But in a photograph, temperature refers to *color temperature*, or the warmth and coolness of the colors in a photograph. *Tint* refers to the reds and greens in your photo. Taken together, temperature and tint are called *color cast*.

Photos in which you might want to adjust the color cast are photos that are shot indoors. Many times these photos have an orange hue because of the lighting in your house. Alternatively, photos that you take in shadow might look too blue. Also, an entire photo can be tinted blue or orange if there is a lot of that particular color in the photograph.

Use the Eyedropper Tool to Adjust Color Cast

There are two methods to adjust the color cast of a photograph. The easiest uses the Eyedropper tool.

1. Select a photograph from your library for which you want to adjust the color cast.

2. Click the Edit button.

3. Click the Adjust tab.

4. Click the Eyedropper tool. Your cursor turns into crosshairs.

5. Move the crosshairs over your photo, and find an area of the photo with a neutral gray or white point to remove its color cast. The color tint and temperature change automatically. Note that it's best to make sure the selected white point isn't completely saturated (as with a bright light source).

6. (Optional) Deselect the Eyedropper tool or use it to click another location of the photograph to change the color temperature and tint again if you so desire.

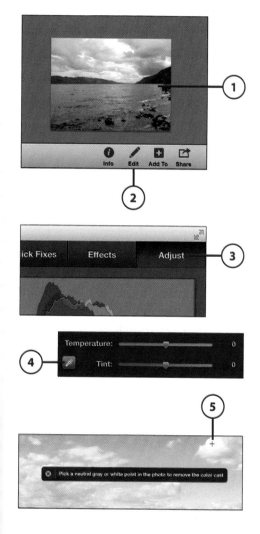

Color Cast Before and After

In the example notice how that in the Before shot, the water took on the same hue as the sky. I used the Eyedropper tool to select a white point on a cloud in the photograph. This told iPhoto to color balance the photo to neutral based on that white point. The result is the same blue sky but a more correct color tone for the water (which was more blue-green) and the sand on the beach (which was darker).

Before

Temperature: 0

Tint: 0

After

Temperature: -18

Tint: 17

Adjust Temperature and Tint Manually

If you want to adjust the temperature or tint of a photograph manually, you use the Temperature and Tint sliders.

1. Select a photograph from your library for which you want to adjust the temperature and tint.

2. Click the Edit button.

3. Click the Adjust tab.

4. Drag the Temperature and Tint sliders until you get the right color cast you want for your photograph.

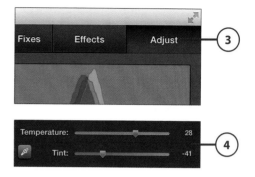

Cool iPhoto Editing Tricks

iPhoto has a number of cool little tricks that a lot of people don't know about. Many of these tricks are very simple, but they go a long way toward helping you edit your photos quickly and easily.

Copy and Paste Edit Adjustments from One Photo to Another

Let's say you've spent half an hour using the Adjust sliders to correct a photo to make the colors and exposures just perfect. That's a big feat, and you want to apply those same changes to other similar photos (such as multiple shots of the same beach taken at the same time) without having to go through all the manual adjustments again.

You're in luck! You can easily copy and paste adjustments from one photo to another.

1. After you've adjusted a photo, select Edit, Copy Adjustments.

2. Select another photo that is similar to the one you have adjusted and that you want to apply the same adjustments to. Usually the easiest way to do this is by using the film roll at the bottom of the editing window.

3. Select Edit, Paste Adjustments and—*voila!*—all your adjustments are applied from the first photo to the second. You can then continue tweaking the adjustments on the second photo if you want. Pretty cool, huh?

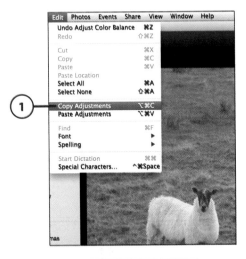

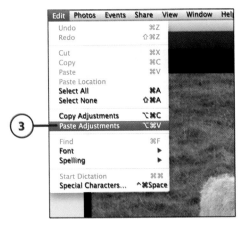

Duplicate Your Photos

Editing your photos is awesome, but sometimes you want to keep the original copy and have a separate, edited copy as well. You can easily do this by using the Duplicate Photo command in iPhoto. This creates two copies of the photo in your iPhoto Library, so only the copy you choose to edit is changed.

1. Select the photo you want to duplicate. Generally, it's a good idea to duplicate it before you've started any edits.

2. Select Photos, Duplicate. You can also press Command+D on your keyboard.

3. The duplicated photo appears next to the original photo in the album or event you duplicated it in. Version 2 is appended to its filename. For example, for an original photograph with the name DSCN0732, the duplicate has the name DSCN0732 – Version 2.

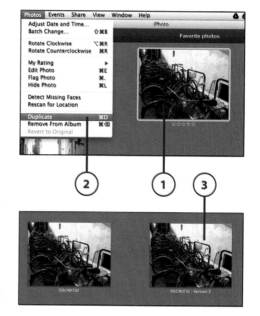

Quickly Review Your Original Pre-edited Photograph

Sometimes when editing a photograph, you wonder just how far you've come. You can, of course, click the Revert to Original button to see the differences, but then you've lost all your edits. You can also duplicate the original photograph, but

this would have to have been done *before* you started editing it. Even if you did duplicate it beforehand, you would have to navigate to the duplicate photo in your iPhoto Library to look at the differences.

Thankfully, Apple added a much easier option. With the press of a single key, you can quickly see how the photo you are editing originally looked.

1. While in Edit mode and with the edited photograph onscreen, press the Shift key at any time to see what the original photo looked like.

2. Release the Shift key to return to the edited photo.

Compare Two or More Photos

Digital cameras have made it easy to record multiple takes of the same image. We quickly rattle off endless shots of our child in front of his first birthday cake like it's going out of style. That's great for recording memories, but when it comes to deciding which of those shots to take the time to edit—because many are so similar—it can be a bit of a headache.

Luckily iPhoto lets you quickly compare two or more shots. This enables you to see them at the same time and choose which one you want to edit.

1. In iPhoto's library, select two or more photos you want to compare. Click and drag the selection box around the photos if they are next to each other, or hold down the Command key on your keyboard and click each photo you want to compare so they are highlighted in a yellow box.

2. Click the Edit button.

3. The photos you have selected to compare appear. Select one of the photos so it is highlighted in a white box. You can then proceed to edit the selected photo.

4. Click to select a new photo to edit from those you are comparing. When you do, a white box appears around it.

5. Select one of the compared photos and then click the X in its upper-left corner to remove it from view.

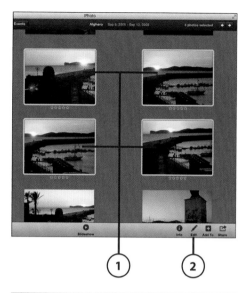

Use Contextual Menu Shortcuts to Edit Photos

While editing a selected photo, you can right-click it to bring up a contextual menu of quick shortcuts. These shortcuts are more ways of carrying out certain editing commands that have already been discussed in this chapter.

1. Select a photograph from your library for which you want to see the histogram.

2. Click the Edit button.

3. Right-click or Control-click a photo to bring up the contextual menu.

4. Choose to rotate, make copying and pasting adjustments, duplicate photos, or revert to the original photograph.

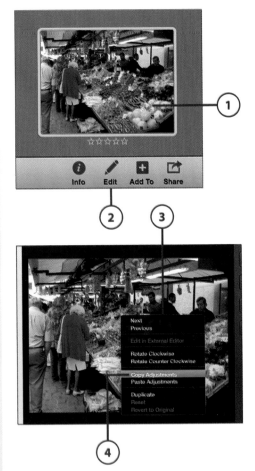

Zoom Using the Keyboard

Zooming can be helpful for looking at a photo you are editing in fine detail. iPhoto has a Zoom slider built in to the iPhoto toolbar, but you can also use a couple of zoom tricks Apple has built in to iPhoto to make zooming easier and more precise. You do this by using the 1, 2, and 0 keys on your keyboard to quickly zoom in to and out of a photograph while editing it. These number keys also perform differently depending on whether your cursor is on the photo or you have moved it to another part of your screen so it is not over your photograph.

Here's a list of ways to zoom using the keyboard when the cursor is not on your photograph:

- Press the 1 key on your keyboard to zoom into the *center* of the photo and view it at 100 percent.

- Press the 2 key on your keyboard to zoom into the *center* of the photo and view it at 200 percent.

- Press the 0 key on your keyboard to zoom back out.

And here's a list of ways to zoom using the keyboard with the cursor over a specific part of your photo that you want to zoom in on:

- Move the cursor to the spot you want to zoom in on and press the 1 key on your keyboard to zoom into the exact spot your cursor is on in the photo and view it at 100 percent.

- Move the cursor to the spot you want to zoom in on, and press the 2 key on your keyboard to zoom into the exact spot your cursor is on in the photo and view it at 200 percent.

- Press the 0 key on your keyboard to zoom back out.

Choose the type of
book you want

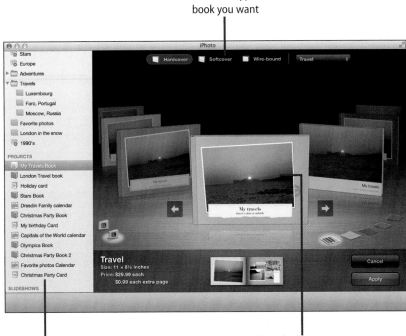

Make books, cards,
and calendars

Decide the way you
want your book to look

In this chapter, you learn all the physical ways to share your photos by creating photo keepsakes such as books, calendars, and cards that you can create and give to your friends and family. It also explores slideshows, the digital keepsake you can share, and having your photos professionally printed via iPhoto.

→ Creating professional-quality photo books

→ Sending greetings with personalized cards

→ Keeping a beautiful annual outlook with calendars

→ Creating stunning slideshows

Creating Keepsakes: Books, Cards, Calendars, and Slideshows

When you have all your photos organized and edited, you'll most likely want to share them with people and not keep them all to yourself. Luckily, iPhoto makes sharing fun and easy. iPhoto lets you share your photos in two ways: electronically and physically. You find these sharing options in the Share button in iPhoto's toolbar. The physical share options are known as creating keepsakes—that is, printed items you can hold.

Keepsakes and the Create Menu

iPhoto has a single powerful button that makes creating keepsakes easy and fun. This button is called the Share button. It looks like an arrow breaking out of a box.

The Share button has three subsections: Share, Create, and Print. The Share submenu handles all of the ways you can share your photos online (which is covered in Chapter 13, "Sharing Your Photos Digitally"). For now, let's concentrate on the Create and Print submenus, which are how you create your iPhoto keepsakes.

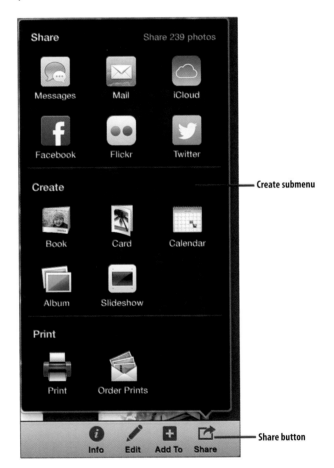

Selecting Book, Card, Calendar, or Slideshow in the Create submenu takes you to that keepsake's theme chooser screen. You can also create a new keepsake by selecting File, New, and then Book, Card, Calendar, or Slideshow from iPhoto's menu bar.

It's Not All Good

TOO MANY MENUS

Apple has made the Share menu a little more crowded than it needs to be. The Create submenu, for instance, is yet another place where you can click to create a new album. This is unnecessary and can actually confuse users because clicking that Album button has nothing to do with creating a physical keepsake.

Before you delve into creating keepsakes, here's a little information about how iPhoto displays your keepsakes in the source list.

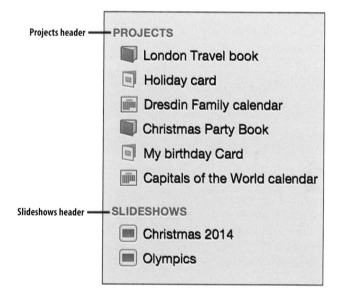

Inside iPhoto's source list are all the keepsakes you have created sorted under two headers: Projects and Slideshows. Collectively, I refer to all of iPhoto's Create submenu items as keepsakes, but for some reason Apple has decided to segregate slideshows from books, cards, and calendars. This results in Books, Cards, and Calendars being placed under the Projects heading and Slideshows being under the Slideshows heading.

You can view any keepsakes you've created by clicking them in the source list. You can also double-click them to change their names.

If You've Created One Keepsake, You've Created Them All

After you know how to create one keepsake—a book, for instance—you know how to create them all. This chapter walks through creating all the different kinds of keepsakes, but it starts with books because they are the most popular. The chapter then covers cards, calendars, and slideshows and notes any of the major differences in creating those keepsakes.

Creating a New Book Project

To get started creating a book, you first need to create a new book project.

1. Select the images you want to use in the book. These can be individually selected images or entire albums or events.

2. Click the Share button.

3. Click the Book button. The book theme chooser screen appears.

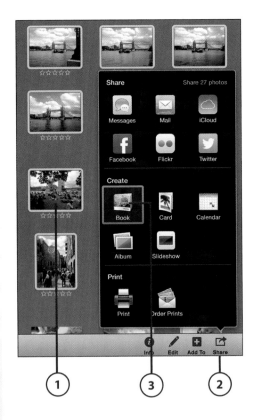

Nothing's Ever Free

iPhoto's ability to enable you to create books, calendars, and cards is great, but remember: You need to pay for the actual item if you want to hold it in your hands. Check out the "Buying Your Keepsakes" section of this chapter for details.

Speeding Up Your Book's Creation

An easy way to speed the creation of a book is to select all the images you want to use in it and move them into a dedicated album. This way, you can simply select the album and then select Book from the Share menu to create a book with those photos. You avoid having to go through your library and clicking each individual photo you want to use in your book.

Work with the Book Theme Chooser

The book theme chooser has several mini-elements and four main interactive elements. The main interactive elements are the ones that enable you to take action and determine the look of your book:

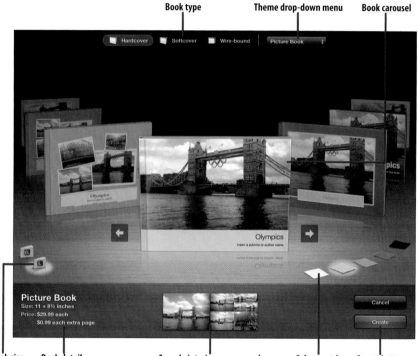

- **Book carousel:** This is a representation of the books available to you. In the examples shown in the carousel, your photos have already been applied to the covers. The book carousel contains a number of different book themes. Each theme provides you with a different look and layout depending on the one you choose. Some examples of book themes are Travel, Picture Book, Journal, and Photo Essay. Click the books to rotate through the carousel.

- **Book type:** iPhoto lets you choose the type of book you want to create. Your options include Hardcover, Softcover, or Wire-bound.

- **Book size:** Books can be made in large or extra-large size.

- **Color swatch:** These colored squares show the available colors for the background pages and cover of a book.

Real-Time Updates

As you change themes and other selections, such as type, size, and color swatches, the images of the books in the carousel change in real time to show you a preview of what the book is going to look like when printed. Also, as you make your selections, the bottom portion of the theme chooser updates to show you a sample spread of the pages inside the book. The sample spread also lists the size and price of each book.

Build a Book

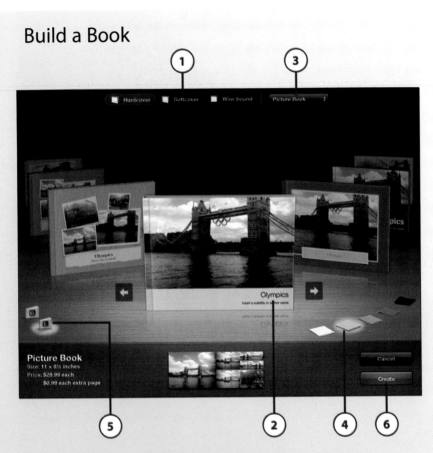

1. Select your book type. Choices are Hardcover, Softcover, or Wire-bound.

2. Select the book's theme from the book carousel. *Or…*

3. …select the book's theme from the Theme drop-down menu.

4. Select the book's color from the color swatches.

5. Select the book's size.

6. Click the Create button.

Work with the All Pages Screen

Once you click the Create button in the theme chooser, you are taken to the All Pages screen. The All Pages screen shows you the exact layout of your book from front cover to back cover.

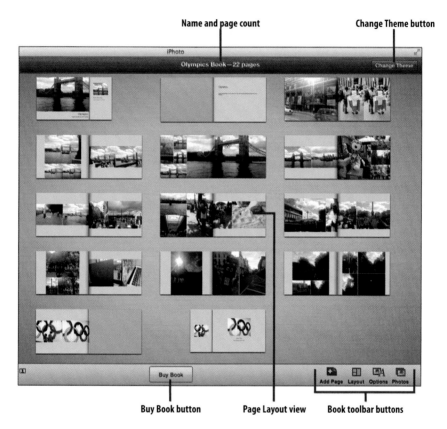

At the top of the All Pages screen, the name of your book project and the number of pages in the book are displayed. You can also click the Change Theme button to return to the theme chooser screen if you don't like the overall theme of the book.

In the main body of the All Pages screen are your book's pages. You can click and drag pages around to sort them into the order you want, or you can simply leave everything as it is and click the Buy Book button. However, if you want to do some fine-tuning with your book, the four toolbar buttons in the lower right of the screen enable you to make any changes you want.

Change the Layout of Individual Pages

You can manipulate the individual layout of your book's pages. There are so many settings and options in the app that it's almost guaranteed no one will ever produce a book with the exact same look and layout as someone else's iPhoto book. As a matter of fact, to show every single option and style combination would require that this book be tens of thousands of pages long. Thankfully, you don't need to see every layout and style option to grasp how to create iPhoto books.

1. Double-click the page you want to change.

2. The selected page is displayed in iPhoto's window.

3. Use the Zoom slider to zoom in on the elements in the page. A navigator window displays to show you which part of your two-page book spread you are zoomed in to.

4. Click the Layout button to open the Layout pane.

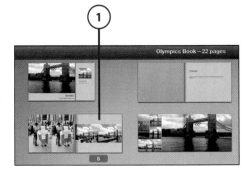

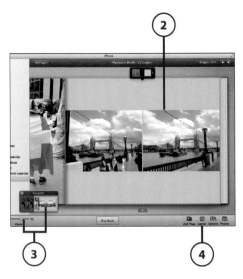

5. Select the color of the page you want as the background behind your pictures.

6. Select the number of photos you want to appear on the page, or the type of page you want it to be. Page types include text, maps, spreads, and even blank pages.

7. Click a thumbnail that has the organization you want on it.

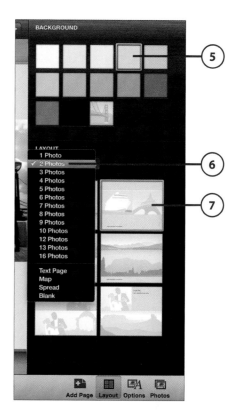

Editing on the Page

You actually don't need to use the Layout, Options, or Photos buttons at the bottom of the Books toolbar. You can completely edit your book's pages on the individual page's screen itself. Simply select a page to bring up it's pop-up layouts and color theme menu or select an image on the page to zoom in and out of it.

Add New Photos to a Page

If you've changed a page's layout and now have some extra space for additional photos, adding those photos to a page is easy.

1. Double-click the gray placeholder for the new photo.

2. The Photos pane opens.

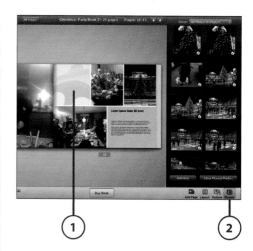

3. Use the Show menu to select what photos you would like to view. Options include All Photos in Project, Placed Photos, Unplaced Photos, the album you are currently working in, all photos from the last 12 months, flagged photos, and more.

4. Drag a photo from the sidebar into the photo placeholder.

5. Zoom in on the photo using the Zoom slider.

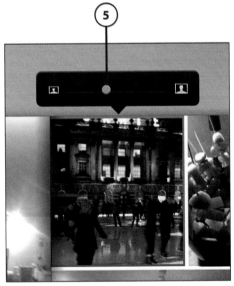

Edit Photos on a Page

You aren't limited to just rearranging your photos and their layout on an individual page. You can also edit and manipulate individual photos on the page as well.

1. Double-click the page you want to change.

2. Double-click the photo you want to edit. The Option pane opens. *Or…*

3. …click the Options button to open the Options pane and then select any photo in the book you want to edit.

4. Select a border to apply to your photo.

5. Choose an effect to add to the photo. Options include B&W, Sepia, or Antique filters.

6. Click the Edit Photo button to go to the regular Edit mode in iPhoto for that image.

7. Use the Zoom slider to zoom in or out of the photo and then click and drag the photo around to place it in your desired position.

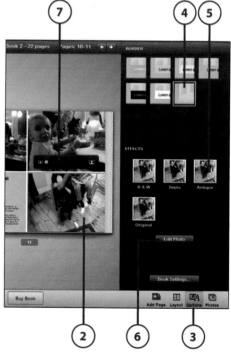

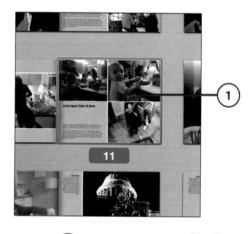

Clear and Autofill All Photos in Your Book

When creating a new book based on a selection of photos (such as an event or album), iPhoto automatically populates the book's pages with the photos from that album. It doesn't do this randomly, however. iPhoto features your higher-rated photos as larger images on the page and also knows to center images with faces in them, so your spouse's face, for example, isn't going to get cut off in the photograph.

However, as you've seen, you can easily manipulate and change the layout of entire pages or individual photos. But if you think you've done too much and got a bit lost, you can also wipe the entire book clean and start new.

1. Click the Photos button in the toolbar.

2. Click Clear Placed Photos.

3. Click Remove to confirm that you want to remove all the photos from your book.

4. To add the photos again manually, click and drag them from the Photos pane to the pages of your choosing. Or...

5. ...click the Autoflow button if you decide iPhoto had laid out the photos better than you did.

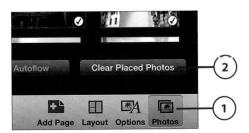

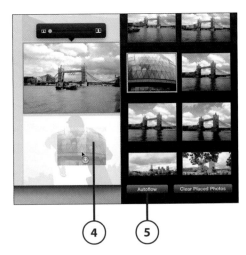

6. Click Autoflow to confirm that iPhoto should automatically fill the remaining pages with photos you have not used.

Autoflow will place all of your unplaced photos at the end of your book. Additional pages will be added to accommodate your photos.

☐ Don't tell me again

Cancel Autoflow

6

Format Text

Many book themes enable you to add text to pages—and alter the placeholder text in keepsakes.

1. Find a page with a text field, click in it, and start typing.

2. Select the text and then choose options from the drop-down menu. From the Quick Format menu, you can change font, text size, and horizontal and vertical alignments. *Or…*

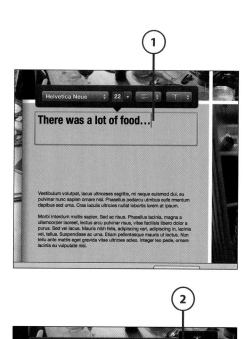

3. …select text and click the Options button to open the Options pane and display all of the additional text-formatting features iPhoto offers.

4. Make your changes using the complete assortment of fonts, text sizes, text colors, alignments, columns, kerning, and spacing options available to you.

5. (Optional) Click the Change Everywhere button if you want to apply the same formatting to all the text in the project.

6. (Optional) Click the Revert to Default button if you've changed your mind about your formatting choices. It undoes your selected text settings and applies the book theme's default text settings to your text.

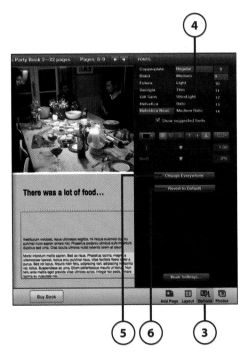

Formatting Text in Cards and Calendars

Apple has made formatting text in projects simple. The process is exactly the same no matter whether you're formatting text in a book, card, or calendar.

FORMATTING WITH CONTEXTUAL MENUS

While editing text, you also have a wide array of contextual menu options just like you do in a word processor. To view them, simply right-click any selected text in a keepsake project to display a contextual menu. Options include checking the spelling, suggesting words, copying and pasting, and looking up a word in the dictionary, among other tools.

Use Maps in Books

Out of the myriad layouts you can choose to have in your book, perhaps one of the coolest is the map layout. Choosing a map layout lets you add a map to your book and mark the locations where your photos were taken. This is an excellent feature to include in a book of travel photos.

1. Click the Add Page button. A new page appears.

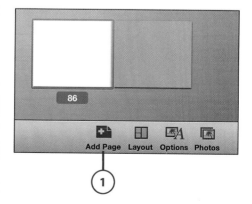

2. Click the Layout button.

3. Choose Map from the Layout drop-down menu.

4. Pick one of the gray map placeholders that appears.

5. Select the new map page.

6. Click the Options button.

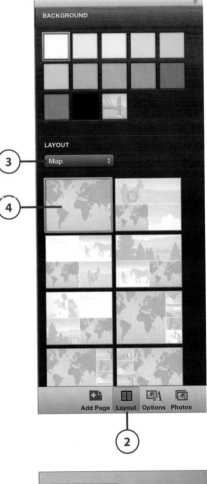

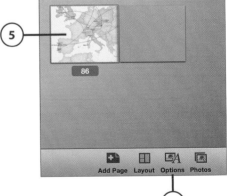

7. Choose one of seven different map styles.

8. Manually add locations to the map by clicking the + button, or if your photos are tagged with GPS data, their locations show up automatically. You can drag the locations up or down in the Places list.

9. Use the Line drop-down menu to apply a connection line to visually show the path you took between the locations.

10. Show or hide other details on the map using the check boxes under the Show heading. These include a title, place markers, a compass, and more.

11. Click the Reset Map button to reset all the map's properties.

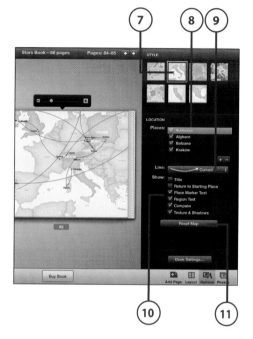

Add Additional Pages to Your Book

Just because you first assembled your book based on a selection of photos doesn't mean you can't add extra pages of photos to your book.

1. Click the Add Page button. A new blank page appears.

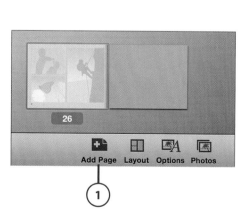

2. Click the Layout button.

3. In the Layout drop-down menu, select the type of page you want to create.

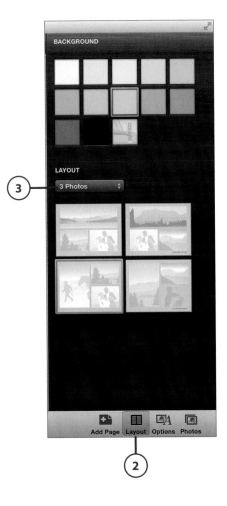

Creating a Card

After you've learned how to create a book in iPhoto, you pretty much know how to create a card and calendar, too. Apple wisely chose to make the creation process and tools the same.

1. Select the image you want to use in the card.

2. Click the Share button.

3. Click the Card button. The card theme chooser screen appears.

Look Familiar?

As you can see, the theme chooser for cards is much the same as the theme chooser for books.

4. Select your card type. Choices are Letterpress, Folded, or Flat.

5. Select the card's theme from the card carousel. Or...

6. ...select the card's theme from the Theme drop-down menu.

7. Select the card's color from the color swatches.

8. Select the card's orientation.

9. After you have made your selections, click the Create button.

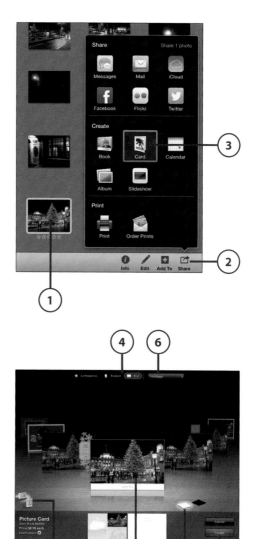

Change the Layout of Your Cards

After you've clicked the Create button in the card theme chooser window, the card layout screen appears. Here you can make changes to your card's layout, such as changing the colors or switching between horizontal and vertical landscapes. You can also enter custom text and stylize the text using the text style options in the Options pane.

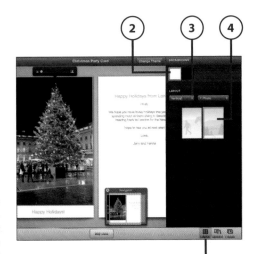

1. Click the Layout button.

2. Select the color of the card you would like.

3. Choose a vertical or horizontal layout.

4. Select a template to use as the cover and interior of the card.

5. Click the Options button and make changes to the photograph used in the card or changes to the text.

6. Click the Photos button and select a new photograph to change the photo used on the card.

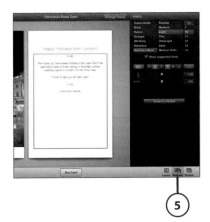

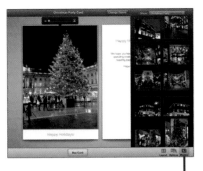

Creating a Calendar

Believe it or not, creating a calendar is even easier than creating a card—at least when it comes to the theme chooser step. To get started creating a calendar, the best thing to do is first group the images you want to use in the calendar into one location, just like you did when creating a book. This single location could be an album or an event. You don't need to put all your images in one location, but doing so just makes it easier for your workflow.

1. Select the images you want to use in the Calendar.

2. Click the Share button.

3. Click the Calendar button. The Calendar theme chooser screen appears.

4. Choose which theme to use, which is the only option you have to specify for a calendar; you can't modify calendars by size or color swatches like you can with books and cards. Navigate through the calendar carousel until you find the right calendar theme. *Or…*

5. …select the calendar theme from the drop-down menu.

6. Click the Create button once you are ready to assemble the calendar. The Calendar Settings dialog box opens so you can determine what data to include in your calendar.

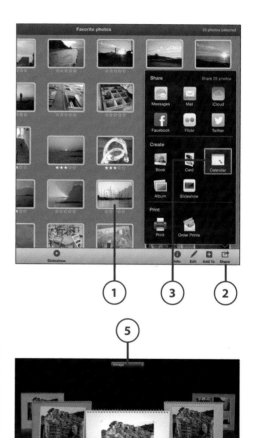

7. Choose the month and year you want your calendar to start on.

8. Decide how many months you want your calendar to contain. You don't always have to do 12; sometimes an 18-month calendar is nice.

9. Select which country's national holidays to display.

10. From the Show Calendars heading, you can select to import events from your Calendar on your Mac. Calendar is OS X's built-in calendar software. Check a particular calendar's check box to include it in your iPhoto calendar.

11. Check Show Birthdays from Contacts if you want any birthdays you have recorded for people in your OS X Contacts to show up on your calendar.

12. Click OK to be taken to the calendar layout screen.

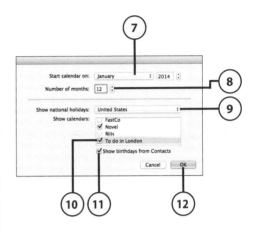

Change Your Calendar Layout

The calendar layout screen displays thumbnails of each page of your calendar. Just as you do with the All Pages view when you create a book, you can drag and drop the picture sections of calendar months to rearrange the images in the calendar.

While in Calendar Layout view, the Layout pane gives you access to all your calendar design settings.

1. Click the Layout button.

2. Select the color of the calendar you would like.

3. Choose between 1 and 7 photos for the month's image.

4. Choose the arrangement of the photos on the calendar page by clicking on the thumbnail placeholder.

5. Click the Options button and make changes to the photograph(s) used in the calendar or make changes to the text.

6. Click the Photos button and select a new photograph.

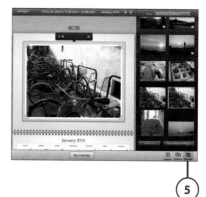

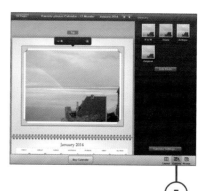

Add Text to Specific Dates

One really cool feature of calendars is the ability to add text to any specific date square on the calendar. This is handy when you want to specify a certain event, such as an anniversary or the beginning of your trip to Europe.

1. From the calendar page layout screen, double-click any date square to display a pop-up window.

2. Enter whatever text you want.

3. Use the font-formatting menu at the bottom of the date square window to format your text, or use the text-formatting options available in the Options pane.

4. When you are done editing and formatting your text, click the X in the upper-left corner of the date square window to close it. You can now view your text on the calendar.

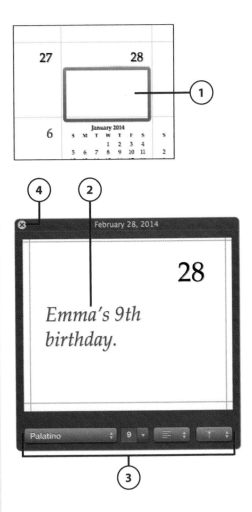

Add Photos to Specific Dates

You can also fill date squares with photos. Perhaps you want to signify your child's birthday with her photograph, or maybe you just want to spice up the calendar page by adding random photos throughout the month.

1. Click the Photos button so your photos are displayed in the pane next to the calendar.

2. Choose the photo you want to fill a date square with, and then drag and drop it onto the date square.

3. Double-click the photo inside the date square to open the date square pop-up window.

4. Use the slider to zoom in or out on the photo and then drag the zoomed image around to place it in the date square how you want it.

5. Add a caption to the photo date by selecting Above, Right, Bottom, or Left from the drop-down menu.

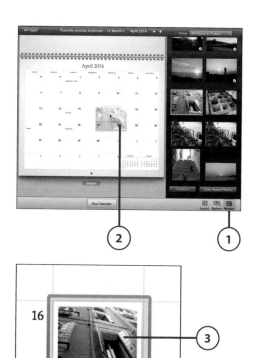

6. Enter text in the caption field. Note that the caption isn't overlaid on the image in the date square; it is placed in the date square above or below, or to the left or right, of the date square with the photo in it. An arrow next to the caption points toward the photo it is referencing.

7. When you are done editing and formatting your date square photo, click the *X* in the upper-left corner of the date square window to close it.

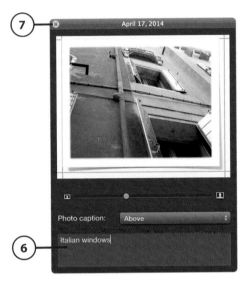

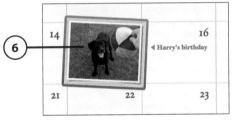

Buying Your Keepsakes

You need to buy the keepsakes when you are done creating them. Actually, you can print them yourself using iPhoto's Print menu found under File, Print in the menu bar, but then you'd have to assemble and bind the book, calendar, or card yourself. It's just much easier (and truthfully, prettier) to let Apple do all the printing for you.

1. Click the Buy Book, Buy Card, or Buy Calendar button at the bottom of your project's window.

2. Double-check what you are ordering and the price of it in the summary window. Enter the quantity you want to purchase and choose your shipping ZIP Code and method. After you have made your selections, click the Check Out button.

3. Enter your Apple ID. If you have an iTunes account, you have an Apple ID. If you need to create an Apple ID, click Create Apple ID Now and then enter your credit card information.

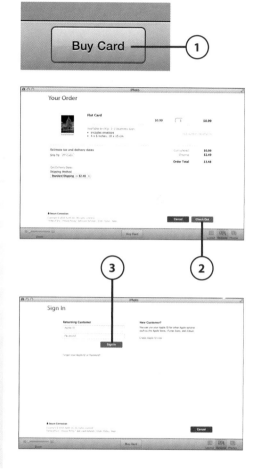

Ordering Prints of Your Photographs

Remember the days when you would take photos with a film camera and then go to your local drugstore to have them printed? It was kind of expensive, somewhat of a pain, and, unless you went to the more expensive one-hour photo places, a long wait before you had nice glossy prints of your photographs.

Nowadays, the traditional print is being usurped by photo-sharing sites (such as Flickr), digital picture frames, and smartphones. However, sometimes it's still nice to have a printed photograph. You can, of course, print your own photos from within iPhoto using File, Print, but that's handy

only if you have a really good photo printer. Consequently, Apple provides a way for you to order physical prints of photos and send them to anyone, anywhere in the world.

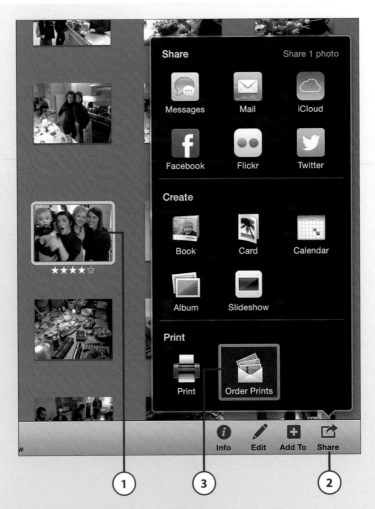

1. Select one or more photos from your iPhoto Library.

2. Click the Share button in iPhoto's toolbar.

3. Click Order Prints.

4. Select the size of each print and the number of copies of each print that you want. For one photo, you can order prints of multiple sizes. As you enter the size and number of prints, the subtotaled cost updates at the bottom of the screen.

5. (Optional) If you know you want the same size and number of copies for all your selected photos, use the Quick Order drop-down menu at the upper right of the order

screen to choose the size, and then choose the number of copies using the up or down arrow.

6. Click the Buy Now button when you are done choosing your print sizes and copies.

7. Enter a shipping ZIP Code.

8. Choose a shipping method.

9. Click the Check Out button.

10. Enter your Apple ID and click Sign In. If you have an iTunes account, you have an Apple ID. If not, you can create one on this screen using the Create Apple ID Now link.

11. Confirm the shipping and credit card details of your order. By default, the shipping address is the billing address associated with your Apple ID. To change it to any other address, click the Edit Shipping link and enter in the new shipping address on the screen that appears.

12. Click Place Order to complete the order.

Creating a Slideshow

Slideshows are great and, unlike other keepsakes, a free way to show off your photos. With a slideshow, you can add text, music, and transitions quickly and easily to your photos and then show your pictures off with the click of a button.

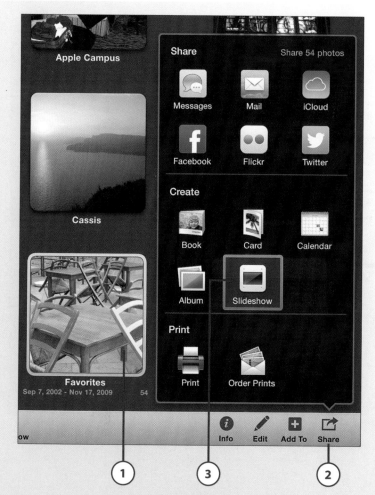

1. Select an album or event to create your show from.
2. Click the Share button in iPhoto's toolbar.
3. Click the Slideshow button. Your slideshow is automatically assembled and listed under the Slideshows header in iPhoto's source list. The slideshow window allows you to browse through the photos in your slideshow one slide at a time. Here you can choose to preview your slideshow, play it, add effects, or export it.

Work with Your Slideshow

To browse through the photos in your slideshow, use the photo browser at the top of the screen. You can click and drag your photos around if you want to change the order they appear in your slideshow. Then, in the slideshow toolbar, you have the following options:

Photo browser

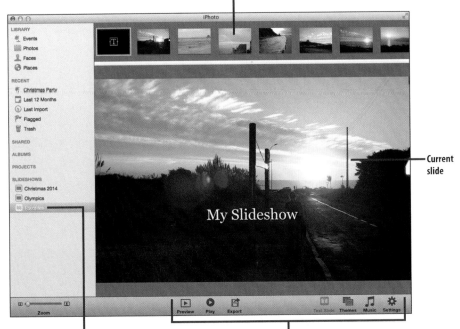

Current slide

Selected slideshow

Slideshow toolbar

- **Preview button:** Quickly previews your slideshow in iPhoto's window. This is handy when you want to see how the show flows from a specific slide (like one in the middle).

- **Play button:** Plays your slideshow from the beginning in full screen.

- **Export button:** Opens the Export dialog box. This also allows you to save your slideshow as a movie, which is then playable on a number of devices, including iPods, iPhones, and iPads.

- **Text Slide button:** Adds a text slide on top of a photo.

- **Themes button:** Shows you the slideshow themes chooser.

- **Music button:** Opens the music browser for your slideshow.

- **Settings button:** Opens the settings options for your slideshow.

Add Text to a Slideshow

Some slideshows only need photos, but by adding text, you can give slideshows more context.

1. Click the Text Slide button.

2. A text field appears over the photo that is displayed in the slideshow window. Enter any text you want.

Choose a Slideshow Theme

iPhoto offers several built-in themes for your slideshows that make you look like you spent hours working on them.

1. Click the Themes button.

2. A dialog box appears showing you the available themes. Move your mouse over the theme to preview it.

3. When you have decided on a theme, click it so it is highlighted with a blue border.

4. Click the Choose button. Your slideshow theme is applied to your show.

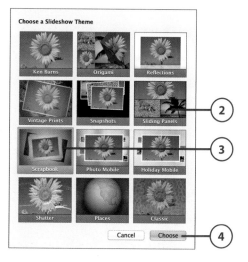

Add Music to a Slideshow

Adding music to a slideshow can give it some much needed "zing!" to keep your audience interested.

1. Click the Music button.

2. A pop-up window appears that displays all your music settings. Basically, if you have music anywhere on your computer, it shows up in the Music Settings box.

3. Choose the music source, such as iTunes, or even a specific playlist, and then choose a song from the list of available music.

4. Preview the song by pressing the triangular Play button.

5. Click the Choose button to apply the song to your slideshow.

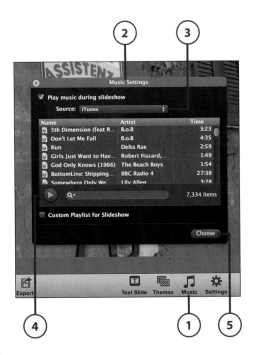

Use Additional Slideshow Settings

iPhoto gives you a number of additional settings that let you tweak your slideshows to your liking. From these settings, you can choose the length of time each slide is displayed, the type of transitions between slides, the aspect ratio of the slideshow, and more. It's best just to play around with all the possible settings to see what you like best because the combinations are virtually limitless.

1. Click the Settings button.

2. A pop-up window appears displaying all the possible settings. The settings are broken down into two tabs: one for all slides and the other for just the selected slide.

3. Make sure the All Slides tab is selected.

4. Choose how long you would like each slide to play for or whether you want to time the slides to fit the music you chose.

5. Choose the type of transitions between slides and the transition speed.

6. Then choose whether you want to show slide captions and titles, whether you want to repeat the slideshow on a loop, whether you want to scale photos to fill the screen, and then select the aspect ratio of your slideshow.

7. Select the This Slide tab and choose to apply Black & White, Sepia, or Antique filters to the photo of the selected slide.

8. Choose how long the individual slide should play.

9. Choose the type of transition for the individual slide and the transition speed.

10. Choose whether you want to apply a Ken Burns effect to the slide.

11. Close the Slideshow Settings window to apply your settings to the slideshow.

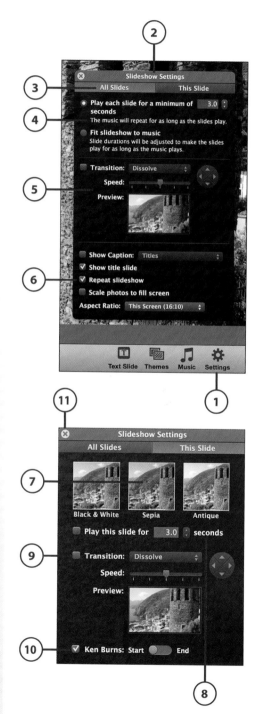

What's a "Ken Burns"?

The Ken Burns effect is named after famous documentary film-maker Ken Burns. Burns pioneered a way to make looking at static photos on screen more interesting by adding a subtle pan and zoom to them. The effect proved so popular with audiences that virtually every documentary—and news report—today uses it.

Play a Slideshow

1. Click the Play button. The slideshow begins to play.

2. Move your mouse while the slideshow is playing to see the onscreen controls. The onscreen controls enable you to play or pause the slideshow; advance to the next slide or go back to the previous one; and quickly access and change the theme, music, and settings for the currently playing show.

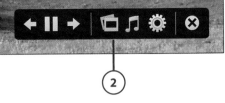

Export Your Slideshow

Sometimes you might want to show your slideshow to someone but they aren't in the same room (or city) as your computer. Good news! They don't need to be. With iPhoto, you can export your slideshow to any iOS device, like an iPhone or iPad, and even save it as a movie so you can email it to people or post it to the Web. Keep in mind that some email services may have a limit on the size of the movie that can be mailed.

1. Click the Export button.

2. Choose a format from the drop-down menu. Format options include 480p, 720p, or 1080p.

3. Check the check box if you want your exported show to be automatically added to your iTunes library. Doing this ensures that it will sync with your iPhone the next time you connect it to your computer.

4. Click Export.

5. Choose the location where you want to save the slideshow.

6. Click OK. The slideshow may take some time to export depending on its size.

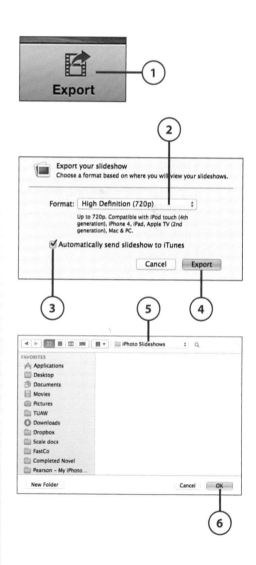

Create an Instant Slideshow

Creating slideshows is cool, but with all the settings options, it can sometimes take a bit of work. If you want to quickly play a selected event, album, or group of photos as a slideshow, you can create an instant slideshow. An *instant slideshow* differs from a regular one in that it is never saved. So, if you create an instant slideshow, it will not show up in the Slideshows header in iPhoto's source list.

1. Choose the album, event, or group of photos you want to play as an instant slideshow.

2. Click the Slideshow button at the bottom of the iPhoto toolbar.

3. The screen fades, and the first image from your selected photos appears. Over the image is a combined settings window. This combined settings window lets you quickly choose your slideshow theme, music, and additional settings, such as transitions and slide duration.

4. Check the Use Settings as Default check box if you want to immediately begin playing future instant slideshows with your current settings.

5. Click the Play button, and your slideshow begins playing.

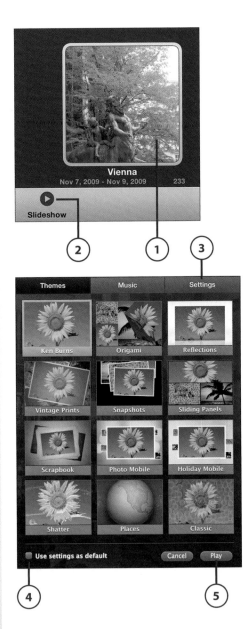

Share via
text or email

Access your photos
in the cloud

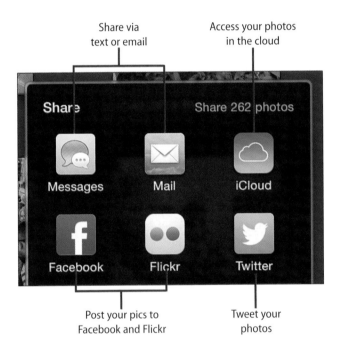

Post your pics to
Facebook and Flickr

Tweet your
photos

In this chapter, you explore all of the digital ways to share your photos. You find out how to easily upload your pictures from iPhoto to iCloud, Flickr, Facebook, and Twitter. You also see how to send those photos via OS X's Messages and via email—all from within iPhoto.

→ Sharing your photos through Apple's iCloud photo streams

→ Uploading your pics to Flickr and Facebook right from iPhoto

→ Sending your pictures to friends via iPhoto's messages and emailing features

→ Tweeting your pics to the world without leaving iPhoto

Sharing Your Photos Digitally

There's no shortage of ways to share your photos digitally in iPhoto. Whether it's by email, social networks, or instant messages, iPhoto lets you share your memories quickly and easily. Most of these ways of digital sharing are accomplished through the all-powerful Share button in iPhoto's toolbar.

When you click the Share button, you see three subsections in the Share menu: Share, Create, and Print. It's the Share subsection at the very top that handles all of the ways you can share your photos online. It contains six buttons: Messages, Mail, iCloud, Facebook, Flickr, and Twitter.

Before you can share your photos using the built-in sharing tools in iPhoto, you need to make sure you have accounts for all six of the digital sharing options—or at least those that you want to use.

As a Mac user, you're entitled to a free iCloud account. Apple's iCloud service gives you access to email, messages, online calendars and contacts, and more. It also enables you to share your photos online. You can sign up for a free iCloud account at www.iCloud.com.

For a Facebook account, head to www.facebook.com, if you don't already have an account there. However, given that there are more than one billion Facebook users, chances are you do.

Flickr accounts can be set up at www.flickr.com. Basic Flickr accounts are free, but the service also offers paid Pro accounts as well.

Twitter is the microblogging site that has taken the world by storm in the last three years. It's where you can post short 140-character "tweets" for all the world to see. It's a powerful tool for keeping track of breaking news and following people you find interesting. A Twitter account is free, and you can sign up for it at www.twitter.com.

For Messages sharing, you need some kind of instant message account. The Messages app in OS X enables you to send instant messages to others via different services. If you have an iCloud or Gmail account, you can use Messages with those existing usernames. Messages also supports AIM and a host of other instant messaging services.

To use iPhoto to email pictures to your friends, you need an existing email account. If you're an iCloud user, you can use your iCloud email address. Other free email accounts are Gmail, Yahoo! Mail, Outlook.com, and more.

Sharing Photos via iCloud

iCloud has a lot of features: email, calendars, and contacts. But the biggest iCloud feature that is integrated with iPhoto is My Photo Stream. My Photo Stream is a feature of iCloud that automatically stores the last 30 days of your photos and pushes them to all your Macs and iOS devices. So, if you take a photo with your iPhone, it's automatically uploaded into your iCloud photo stream and will appear on your iPad and Mac, inside iPhoto. This is a great feature as it enables you to access all your photos no matter which device you are on.

Set Up Your iCloud Account

Before you can use My Photo Stream on your Mac, you must set up iPhoto to use your iCloud account.

1. Select System Preferences from the Apple menu on your Mac.

2. Click iCloud.

3. Enter your iCloud username and password.

4. Make sure Photos is enabled in the iCloud Settings pane by checking its box.

5. Click the Options button.

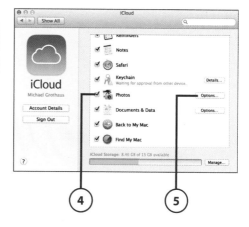

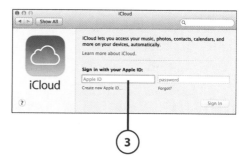

6. Check both My Photo Stream and Photo Sharing to enable them for use. iPhoto displays photo stream events in the app.

Photo Stream Events

The photo stream events are grouped into months and appear as auto-generated events under Events in the source list. Each has a heading in the format of "Month, Year, Photo Stream," such as "Dec 2013 Photo Stream."

These auto-generated monthly photo stream events are great— as long as you open up iPhoto on your Mac once a month. All the pics you snap on your iPhone or iPad are automatically downloaded to iPhoto on your Mac; there's no longer a need for you to sync your iPhone and iPad to import the pictures.

Auto-generated photo stream events

Turn Off Automatic Uploading to iCloud

The My Photo Stream feature of iCloud is awesome for enabling you to have your pics on all your Apple devices without needing to manually sync them. However, if you use a dedicated digital camera and import those pictures to iPhoto, iPhoto automatically uploads them all to your photo stream. This means your photo stream could get very crowded. In this case, it's best to turn off automatic uploading in iPhoto.

1. Select iPhoto, Preferences.

2. Click the iCloud tab.

3. Uncheck the Automatic Upload option. When you've turned off automatic uploads, any photos imported to iPhoto will not be uploaded to your photo stream unless you manually add them.

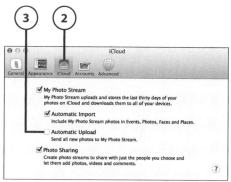

Manually Add Photos to My Photo Stream

1. Select the photos you want to upload.

2. Click the Add To button.

3. Click the iCloud button.

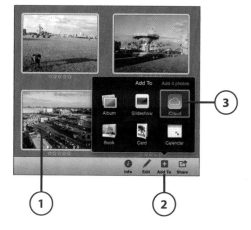

4. Click the My Photo Stream button.

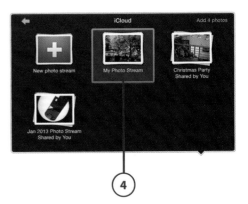

Delete Photos from My Photo Stream

If for whatever reason you want to delete a photo from My Photo Stream, you can easily do it right from iPhoto.

1. Choose iCloud from under the Shared header in iPhoto's source list.

2. Click My Photo Stream.

3. Select the photos you want to delete and press the Delete key on your keyboard.

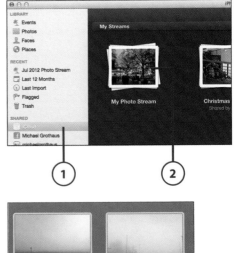

4. Click Delete Photos in the confirmation dialog box.

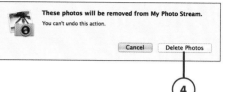

Turn Off My Photo Stream

My Photo Stream not your thing? You can turn it off all together.

1. Select iPhoto, Preferences.

2. Click the iCloud tab.

3. Uncheck the Automatic Upload option.

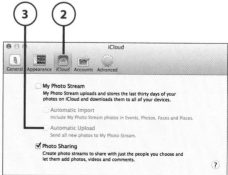

4. Click Turn Off in the confirmation dialog box. *Or...*

5. ...click Import Photos and Turn Off to first import the existing photos from My Photo Stream into your iPhoto Library.

Turning off My Photo Stream will remove photos from the iCloud Photos view.

You can import photos into your library before turning off My Photo Stream.

[Import Photos and Turn Off] [Cancel] [Turn Off]

⑤ ④

Sharing Photo Streams

iCloud photo streams aren't a solitary endeavor. You can use photo streams to share pictures with your family and friends, or the world at large. Sharing photo streams with others enables them to view your pictures inside their own versions of iPhoto and "like" and comment on them. To do this, however, they too must be iCloud members.

If you want to share your photo stream pics with people who aren't iCloud members, you can do so via a web link, which enables them to view your photo stream pics online, although they won't be able to "like" or comment on them.

Enable iCloud Photo Sharing

Before you can share your iCloud photo stream, you must first enable iCloud photo sharing.

1. Select iPhoto, Preferences.

iPhoto	File	Edit	Photos	E\
About iPhoto				

① Preferences... ⌘,

Empty iPhoto Trash ⇧⌘⌫

Learn about Print Products
Learn about Aperture
Provide iPhoto Feedback

Services ▶

Hide iPhoto ⌘H
Hide Others ⌥⌘H
Show All

Quit iPhoto ⌘Q

2. Click the iCloud tab.

3. Check the Photo Sharing option.

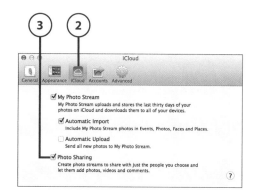

Create a Shared Photo Stream

1. Select the photo or photos you want to publish from the library. You can also choose to publish an entire event or album by selecting the event by clicking it or choosing the album by clicking it in iPhoto's source list.

2. Click the Share button.

3. Click iCloud.

4. Click any existing photo streams in your iCloud account to add your currently selected photos to that photo stream. You'll get a confirmation that the photos were uploaded to it, and then you are done. *Or...*

5. ...click the New Photo Stream button to create a new photo stream.

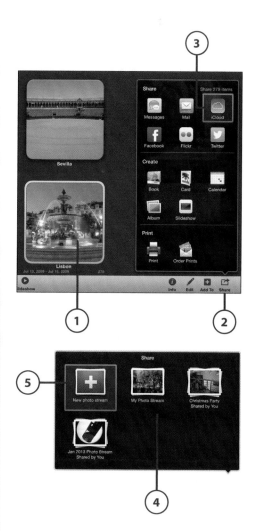

6. Enter the email addresses of the people you want to share your photo stream with.

7. Name your photo stream. By default, this is the name of the event or the iPhoto album from which you are uploading the photos. You can change it to any name you want in the text box.

8. Add your own comments to the photo stream to provide people with a description of the photos.

9. Check Subscribers Can Post so those with access to the photo stream are able to add their own pictures and videos to the photo stream.

10. Check Public Website so that anyone with the photo stream URL is able to view the photos on it.

11. Click the Share button.

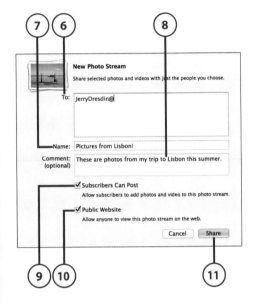

View and Manage Your Shared Photo Streams

After you have published photos to your iCloud photo stream, you can view them in iPhoto or on the Web. You can also manage their settings at any time.

1. Select your iCloud account in iPhoto's source list under the Shared header. Your iCloud photos are displayed in the body of iPhoto's window.

2. Double-click the photo stream you want to view.

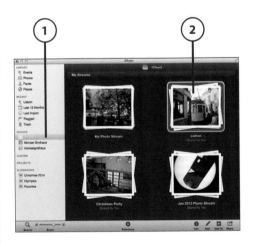

3. Click the Info button. In the Information Pane that appears, you can manage your photo stream settings.

4. Enter more email addresses in the Subscribers box to add subscribers to your photo stream, or you can select an existing name and press Delete on your keyboard to remove someone.

5. Check or uncheck Subscribers Can Post to toggle whether subscribers can upload photos and videos to your photo stream.

6. Check or uncheck Public Website to change the status of the photo stream.

7. Click the URL to view your photo stream in a web browser.

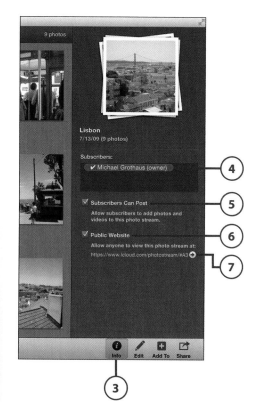

Delete Individual Photos from a Shared iCloud Photo Stream

If you want to delete a photo from a shared photo stream, you can easily do this right from iPhoto.

1. Choose iCloud from under the Shared header in iPhoto's source list.

2. Click the shared photo stream that contains the photos you want to delete.

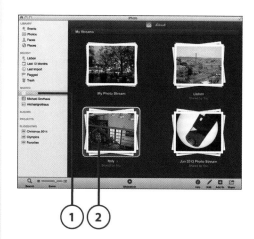

3. Select the photos you want to delete and press the Delete key on your keyboard.

4. Click Delete Photos in the confirmation dialog box.

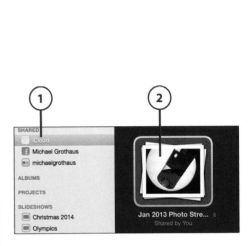

Delete a Shared iCloud Photo Stream

If you want to delete an entire shared photo stream, you can easily do that, too.

1. Choose iCloud from under the Shared header in iPhoto's source list.

2. Select the shared photo stream that you want to delete and press Command+Delete on your keyboard.

3. Click Delete in the confirmation dialog box. The photo stream is removed from your iCloud account; however, its photographs still remain in your main iPhoto Library if that is where they originated.

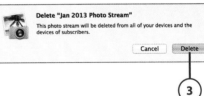

Save Photos Added by Others

When someone has uploaded a photo to your photo stream, the next time you open iPhoto, the photo stream syncs in iPhoto and displays any photos your friends have uploaded.

However, these synced photos have not been saved to your iPhoto

Library. If you choose to delete the
photos or the photo stream from
your iCloud account, any photos your
friends have uploaded to your photo
stream will be deleted for good. So,
before you delete an iCloud photo
stream or individual photo in a photo
stream through iPhoto, make sure
you've saved any photos your friends
have uploaded first.

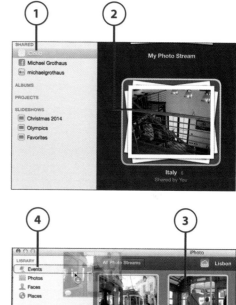

1. Choose iCloud from under the
 Shared header in iPhoto's source
 list.

2. Double-click the shared photo
 stream that contains the photo or
 photos you want to save.

3. Select the photo or photos you
 want to save.

4. Drag the photos to your Photos or
 Events header in iPhoto's source
 list to add them to your iPhoto
 Library.

Sharing Photos via Flickr

Flickr has been a popular image hosting site since its launch in 2004. If you're
a current Flickr member, you'll be happy that Apple has built-in Flickr support
in iPhoto. If you're not a member yet, you can go to www.flickr.com to create
a free account.

Set Up Your Flickr Account to Use in iPhoto

If you have a Flickr account, you can sign in to it in iPhoto so you can begin sharing your photos to your Flickr page.

1. Select iPhoto, Preferences.

2. Click the Accounts tab.

3. Click the + button to add a new account.

4. Select Flickr.

5. Click the Add button.

6. Click Set Up to confirm that you want to set up iPhoto to use with Flickr. On the Yahoo!/Flickr login page (not shown), enter your login details.

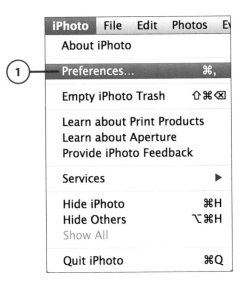

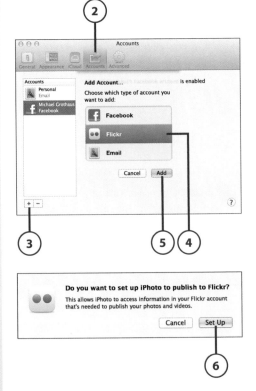

7. Click the Next button to indicate that you arrived at this page because you specifically asked iPhoto Uploader to connect to your Flickr account.

8. Click OK, I'll Authorize It.

9. Close your web browser and return to iPhoto where your Flickr account is now enabled.

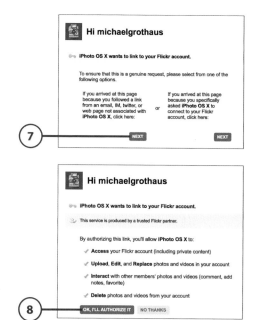

Publish Photos to Flickr

1. Select the photo or photos you want to publish. You can also choose to publish an entire event or album. To do so, simply select the event by clicking it, or choose the album by clicking it in iPhoto's source list.

2. Click the Share button.

3. Click Flickr. The Share menu expands to become the Flickr Sets menu.

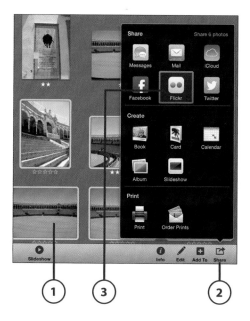

4. Click New Set, which creates a new photo set on your Flickr page containing the photos you have selected. (A *set* is what Flickr calls an album.) Skip to step 7. *Or…*

5. …click the Photostream button to add the selected photos right to your Flickr photostream. Skip to step 8. *Or…*

Flickr Photostream Versus iCloud Photo Stream

A *photostream* on Flickr is simply a collection of the latest photos you've uploaded. A Flickr photostream is completely different than iCloud's photo stream.

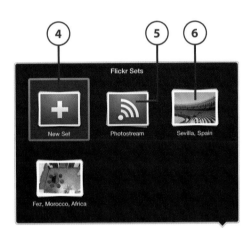

6. …click any of the existing Flickr sets you've already created to add your currently selected photos to that set. Skip to step 8.

7. Enter the set's name.

8. Use the Photos Viewable By drop-down menu to set your photos' privacy settings. Choose who can view them, including you, just your friends, just your family, both your friends and family, or anyone.

9. Use the Photo Size drop-down menu to set the size of your uploaded photos. You can choose from three options: Web, Half-size, or Full-size.

10. Click Publish. Your photos begin uploading to your online Flickr account.

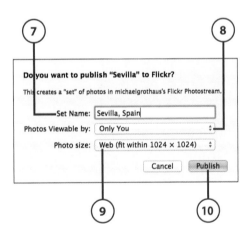

View Your Flickr Sets

After you have published photos to Flickr, you can view them in iPhoto or on the Web.

1. Select your Flickr account in iPhoto's source list under the Shared header. Your Flickr sets are displayed in the body of iPhoto's window.

2. Double-click the set you want to view. *Or...*

3. ...click the link at the top to open up your web browser and view your images on Flickr.com.

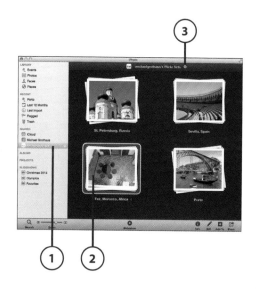

Delete Photos from a Flickr Set

If you want to delete a photo from a Flickr set, you can easily do this right from iPhoto.

1. Choose your Flickr account in iPhoto's source list.

2. Double-click the set the photos are in.

3. Select the photo or photos you want to delete and press the Delete key on your keyboard.

4. Click Remove Photo in the confirmation dialog box.

5. Click Delete to confirm you want to remove the photo.

Deleted from Flickr, Not iPhoto

The photos are removed from your online Flickr account; however, if you uploaded them from your iPhoto Library, they still remain in your main iPhoto Library. Any photos synced from Flickr that have not been manually imported to your iPhoto Library are moved to iPhoto's trash unless you choose to import them first.

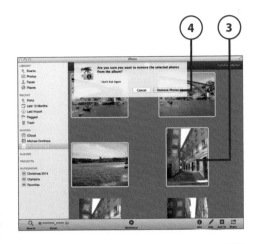

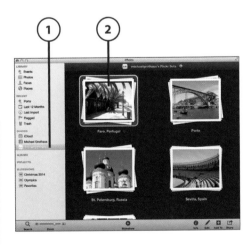

Delete a Flickr Set

1. Choose your Flickr account in iPhoto's source list.

2. Select the set you want to delete and press Command+Delete on your keyboard.

3. Select whether you want to import the photos to your iPhoto Library before deleting the Flickr set.

4. Click Delete Set if you want to delete only the set and have the photos in the set still reside in your Flickr photostream online. *Or...*

5. ...click Delete Set and Photos if you want to delete both the set and the photos it contains.

6. Click Delete Set or Delete Set and Photos to confirm. Depending on the option you choose, the set and/or its contents are removed from your online Flickr account. Any photos downloaded from Flickr that have not been imported to your iPhoto Library are moved to iPhoto's trash unless you choose to import them first.

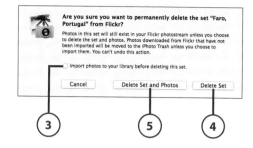

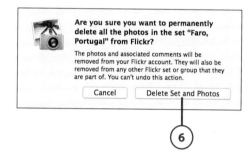

Save Photos Added by Others

Flickr allows you or others to add photos to your sets via the Web and email. When someone uploads a photo to your Flickr account, the next time you open iPhoto, your Flickr sets sync in iPhoto and display any photos that have been added to your sets through sources other than iPhoto.

However, these photos have not been saved to your iPhoto Library, and if you choose to delete the photos or sets from your Flickr account, any photos uploaded to your

account outside of iPhoto are delet-
ed as well. Before you delete a Flickr
set or photo through iPhoto, make
sure you've saved any photos you
want to keep that were not originally
part of your iPhoto Library.

1. Choose your Flickr account in
 iPhoto's source list.

2. Choose the set the photos are in.

3. Select the photo or photos you
 want to save.

4. Drag the selected photos to your
 Photos or Events header in iPho-
 to's source list. This adds them
 to your iPhoto Library, so even if
 you delete them from your Flickr
 account, you still have them saved
 on your computer.

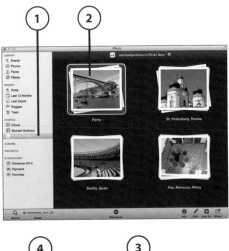

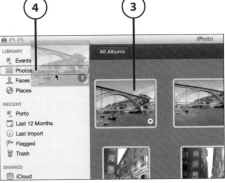

Sharing Photos via Facebook

Unless you live under a rock, you've heard of Facebook. It's the wildly
popular social networking site that has more than a billion members and has
spawned an Oscar-winning movie. Facebook lets you keep in touch with your
friends, send messages, chat, play games, and, yes, upload and post photos.

Of course, given Facebook's massive popularity, it's no surprise Apple has
built-in Facebook photo sharing to iPhoto.

Set Up Your Facebook Account to Use in iPhoto

If you have a Facebook account, you can sign in to it in iPhoto so you can begin sharing your photos to your Facebook page.

1. Select iPhoto, Preferences.

2. Click the Accounts tab.

3. Click the + button to add a new account.

4. Click Facebook.

5. Click the Add button.

6. Enter the email associated with your Facebook account.

7. Enter your Facebook password.

8. Check the box stating you agree to Facebook's terms.

9. Click Login.

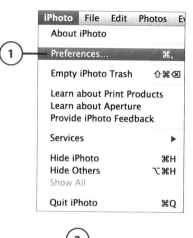

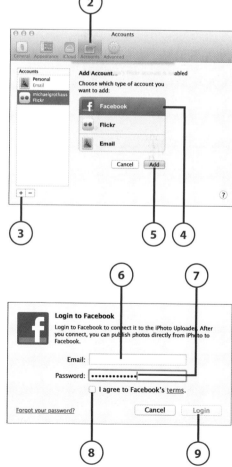

Publish Photos to Facebook as Albums

1. Select the photo or photos from your iPhoto Library that you want to publish. You can also choose to publish an entire event or album. To do so, simply select the event by clicking it, or choose the album by clicking it in iPhoto's source list.

2. Click the Share button.

3. Click Facebook. The Share menu expands to become the Facebook Albums menu.

4. Add photos to an existing Facebook album by clicking that album. You see a confirmation that the photos were uploaded to it, and then you are done. Or...

5. ...click the New Album button.

6. Enter the album name. By default, the album is named with the title of the event or iPhoto album you are uploading the photos from. You can change it to any name you want in the text box.

7. Choose your photos' privacy settings in the Photos Viewable By drop-down menu. Options include Everyone, Friends of Friends, Only Friends, or Only Me.

8. Click Publish. Your photos begin uploading to a new album in your Facebook gallery.

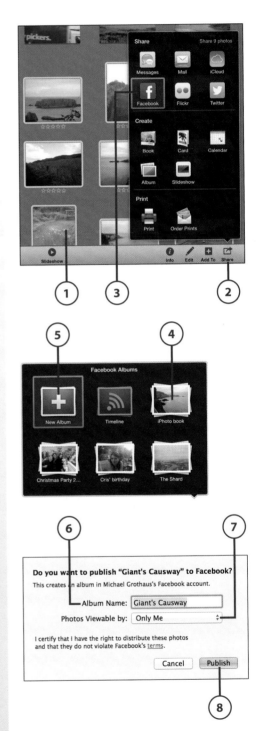

View and Manage Your Facebook Albums

After you have published photos to Facebook, you can view them in iPhoto or on the Web.

1. Select your Facebook account in iPhoto's source list under the Shared header. Your Facebook albums are displayed in the body of iPhoto's window.

2. Double-click the album you want to view.

3. (Optional) Click the Info button. The Information Pane displays very limited information for the selected album. This information includes the name of the album, the dates its photos were taken, and how many photos the album contains.

4. (Optional) Enter a brief description of the album if you want.

5. (Optional) Change who has access to view the albums via the drop-down menu. Choose from Everyone, Friends of Friends, or Only Friends.

6. Click the link at the top to open up your web browser and view your images on Facebook.com.

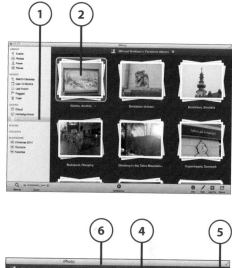

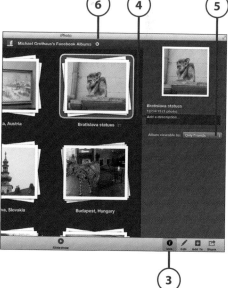

Publish a Photo to Your Facebook Timeline

The primary feature of Facebook is the Timeline. It's where you can post status updates, links, and individual photos. iPhoto lets you quickly and easily post a single photo to your Timeline. Keep in mind that you can post only one photo to your Timeline at a time. If you have multiple photos selected, you will not be able to select the Timeline button.

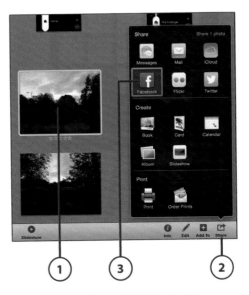

1. Select the photo you want to post to your Timeline.

2. Click the Share button.

3. Click Facebook. The Share menu expands to become the Facebook Albums menu.

4. Click the Timeline button.

5. Select who the photo is viewable by: Everyone, Friends of Friends, Friends, or Only Me.

6. Add a comment about the photo if you want. This comment appears on your Timeline beneath the photo.

7. Click the Publish button, and your photo and its comment are posted to your Timeline. Note that photos you have uploaded to your Timeline do not appear in your Facebook albums in iPhoto.

Change Your Facebook Profile Picture from Within iPhoto

iPhoto allows you to change your Facebook profile picture from within iPhoto itself.

1. From your iPhoto Library, select the photo from your iPhoto Library that you want to use as your profile picture. Make sure to edit and crop it to your liking before you upload it.

2. Click the Share button.

3. Choose Facebook. The Share menu expands to become the Facebook Albums menu.

4. Click the Profile Picture button.

It Only Works with One

Note that you see the Profile Picture button when you have only one photo selected. If you have more than one photo selected, the button is not displayed.

5. Click Set to confirm that you want to set the photo as your profile picture.

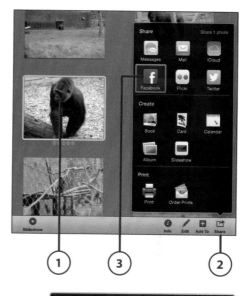

Delete Photos from a Facebook Album

1. Choose your Facebook account in iPhoto's source list.

2. Double-click the album the photos are in.

3. Select the photo or photos you want to delete and press the Delete key on your keyboard.

4. Click Remove Photo to confirm that you want to remove the selected photo(s).

5. Click Delete in the confirmation dialog box.

Removed from Facebook, Not iPhoto

The photos are removed from your online Facebook account; however, if you uploaded them from your iPhoto Library, they still remain in your main iPhoto Library. But any photos synced from Facebook that have not been manually imported to your iPhoto Library are moved to iPhoto's trash unless you choose to import them first.

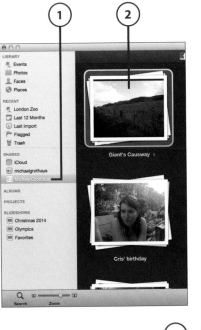

Delete Entire Facebook Albums

1. Choose your Facebook account in iPhoto's source list.

2. Select the album you want to delete and press Command+Delete on your keyboard.

3. Click Delete in the confirmation dialog box, and your album is deleted from your online Facebook account. Any photos synced from Facebook that have not been imported to your iPhoto Library are moved to iPhoto's trash unless you choose to import them first.

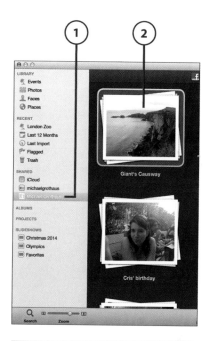

Save Photos Added to Facebook Albums Outside of iPhoto

Facebook allows you to add photos to your account via the Web. When you externally upload a photo to your Facebook account, the next time you open iPhoto, your Facebook albums will sync in iPhoto and display any photos that have been

added to your albums through sourc-
es other than iPhoto.

However, these photos have not
been saved to your iPhoto Library,
and if you choose to delete the pho-
tos or albums from your Facebook
account, any photos uploaded to
your account outside of iPhoto are
deleted as well. So, before you delete
a Facebook album or photo through
iPhoto, make sure you've saved any
photos that were not originally part
of your iPhoto Library.

1. Choose your Facebook account in
 iPhoto's source list.

2. Choose the album the photos
 are in.

3. Select the photo or photos you
 want to save.

4. Drag that photo or photos to your
 Photos or Events header in iPho-
 to's source list. This adds them to
 your iPhoto Library, so even if you
 delete them from your Facebook
 account, they are still saved on
 your computer.

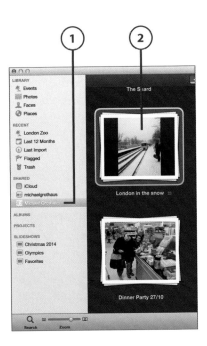

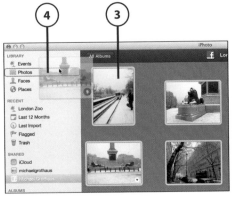

Sharing Photos via Messages

Messages is OS X's instant messaging app. It comes free in OS X 10.8 or above. With it, you can chat to people via your GoogleTalk, iCloud, AIM, and Yahoo! accounts. You can also send up to 10 photos at a time in your chat via Messages right from within iPhoto.

Set Up Your Messages Account to Use in iPhoto

Before you can use the Messages sharing function in iPhoto, you must first have the Messages app on your Mac set up for use. To do this, you need an existing Apple ID, or a GoogleTalk, Yahoo!, or AIM ID.

1. Click the LaunchPad icon in the Dock.

2. Click the Messages app.

3. Enter your Apple ID username and password. (Your Apple ID username is your @icloud. com email or the same email and password you log in to the iTunes Store with.)

4. Click the Sign In button.

5. (Optional) If you don't want to use your Apple ID, click the Not Now button.

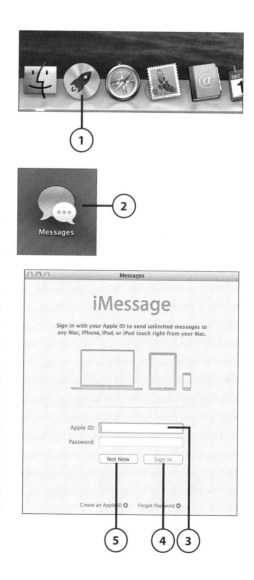

6. Choose the service of the existing ID you want to use.

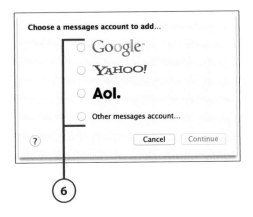

Share a Photo via Messages

After you've set up Messages on your Mac, sharing a photo via Messages is easy.

1. Select the photo or photos you want to send (you can choose up to 10).

2. Click the Share button.

3. Click the Messages button.

4. Enter the name of your recipients in the message window.

5. Add a text message to the photo if you want.

6. Insert a smiley face or other emoticon if you want.

7. Click Send.

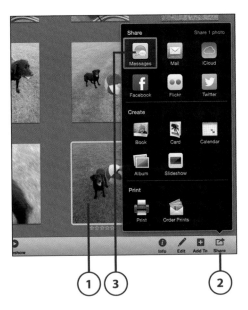

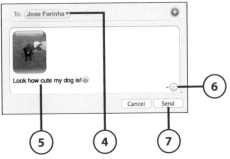

Sharing Photos via Twitter

Twitter is the hot new social network on the Net. It has Facebook quaking in its boots and the media world in love with it. If you have a Twitter account, you can tweet one photo at a time right from iPhoto. Note, however, that each photo takes up 21 characters (for the image URL) out of your 140-character tweet limit.

Set Up Your Twitter Account to Use in iPhoto

Before you can tweet from within iPhoto, you must first have your Twitter account set up on your Mac. This only takes a few seconds and you only have to do it once.

1. Select System Preferences from the Apple menu.

2. Click Internet Accounts.

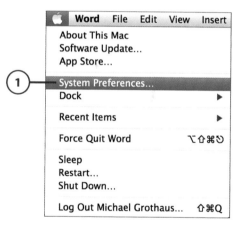

Internet Accounts

3. Click Twitter.

4. Enter your Twitter username and password.

5. Click Next.

6. Allow all of OS X to access your Twitter account by clicking Sign In.

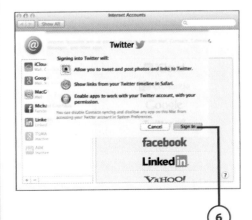

Share a Photo via Twitter

After you've set up your Twitter account on your Mac, you'll be tweeting your photos in no time.

1. Select the photo you want to send (you can only choose one).

2. Click the Share button.

3. Click the Twitter button.

4. Enter any text you want to tweet with your photo. Remember, you only have about 123 characters left of your 140-character total.

5. Click the Add Location button if you want to embed your current location in the tweet.

6. Click Send, and the tweet is sent.

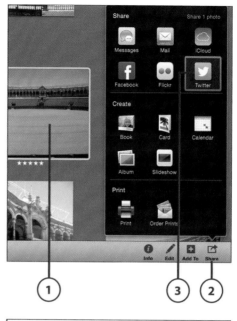

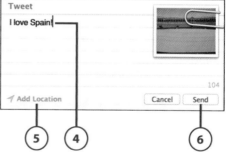

Sharing Photos via Email

It wasn't long ago that email was the preferred way to share digital photos. Now, however, with the rise of social networking sites, email is quickly being usurped. In fact, email usage has dropped more than 40% in the last five years, largely because of social networking sites and texting. Maybe, however, people just need a cooler way to email their photos. That's where iPhoto comes in.

Using iPhoto, you can create cool themes in the body of your email to display your photos. These themes allow you to arrange your photos in interesting

ways, kind of like if you were laying them out on a poster. You can then add and format your own text, change the layout of the photos, and more, all from within iPhoto!

iPhoto offers 10 email themes, including classic, journal, snapshots, corkboard, cardstock, announcement, celebration, collage, letterpress, and postcard. However, Apple frequently issues new, free updates to iPhoto, which might include new themes from time to time.

Set Up an Email Account to Use with iPhoto

Before you can send photos from within iPhoto, you need to make sure you've entered your email information. If you are already using OS X's Mail app, iPhoto automatically imports your email information and settings, so you're ready to go. If you check your email only in a web browser, however, you need to manually enter your email settings in iPhoto.

1. Choose iPhoto, Preferences.

2. Select the Accounts tab. The Accounts pane appears and displays any accounts you already have set up.

3. Click the + button.

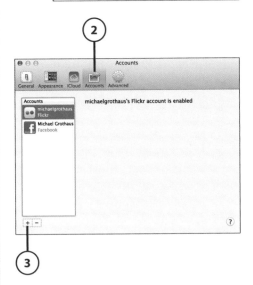

4. Select Email in the Add Account box.

5. Click Add.

6. Select your email provider and then click OK.

7. Enter your email account information, and click OK. Your username and password are validated, and the account is added to the Accounts list.

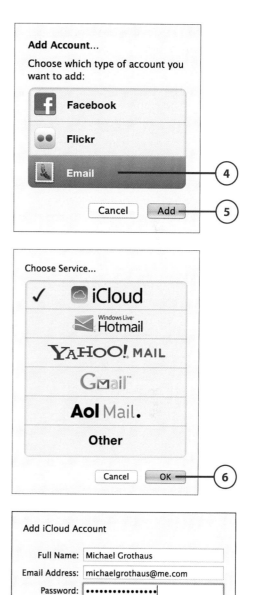

Email Photos from Within iPhoto

After you have set up your email account, you are now ready to use iPhoto's built-in email features.

1. Select the photos you want to email. You can choose up to 10 photos to email in one message if you are using any of the themes. However, if you want to send more than 10 photos at a time, you're limited to the Classic and Journal themes.

2. Click the Share button.

3. Click Mail.

4. Enter the email addresses of the recipients.

5. Enter the subject of your email.

6. If you have more than one email account set up in iPhoto, select the email account you want to send your email from.

7. Choose which theme you want to display your photos in in the body of the email.

8. Check Attach Photos to Message if you want to include downloadable versions of the photos you are sharing as a single attachment. This option allows your recipient to save the photos to his or her computer and not just view them in the body of the email. If you choose not to include the photos as an attachment, the email contains only what you see in the body of

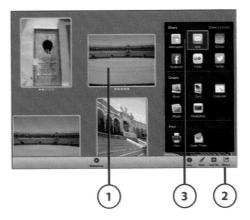

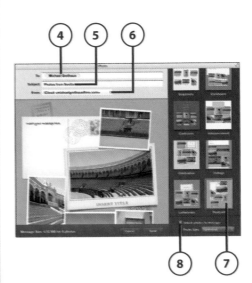

the message, effectively a single image of text and photos.

9. Use the Photo Size drop-down menu to choose the size of your photo attachments, including Optimized (which chooses the best size for emailing), Small, Medium, Large, or Actual Size.

10. Enter text into any of the text holders in the body of the email.

11. Adjust fonts and sizes using the pop-up menus that appear when you are editing a text field.

12. Select any of the photos to show the Zoom slider, then drag it to zoom in or out.

13. Click and hold a photo to drag it around the frame. Drag photos from one frame to the next to swap their positions.

14. Click the Send button, and your email is sent.

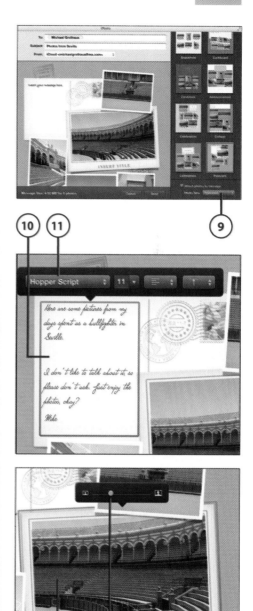

Viewing Sharing Information for a Photo

iPhoto keeps an entire history for each photo you share. This is helpful in keeping track of where your photos are being published.

1. Select the photo.

2. Click the Info button.

3. Click the Sharing header so it's expanded and you can see all the ways you've shared the selected photo, including the dates and times you shared it. Information that shows up in the Sharing header can show you any of the following: email and messages history, Twitter, Facebook shares, and Flickr and iCloud photo streaming publishings.

4. Click any link arrow to go to the website the photo was shared on (for example, Twitter or Flickr).

5. Any comments or likes you have received on the photo also show up under the Comments header.

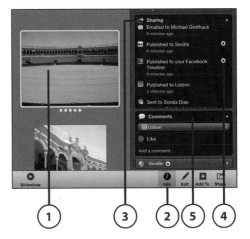

Setting a Photo as Your Desktop Picture

Sometimes it's just cool to display your favorite photo as your desktop picture. Apple has made it easy to do this from within iPhoto.

1. Select the photo you want to use as your desktop picture.

2. Select Share, Set Desktop. The selected photo appears as your desktop picture.

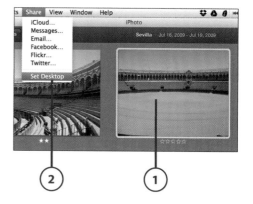

SETTING MULTIPLE PHOTOS AS YOUR DESKTOP PICTURE

You can also use multiple photos as your desktop picture. If you select multiple photos and then select Share, Set Desktop, the first photo selected is set as the desktop picture. After a period of time, the desktop picture automatically changes to the next photo in the sequence. You can adjust the length of time it takes for this to happen in your Mac's System Preferences. Select System Preferences from the Apple menu, and then click Desktop & Screen Saver. Choose the Screen Saver tab, and select the length of time to change the desktop picture from the Change Picture drop-down menu.

>>>Go Further

Index

CHECK OUT MUST-HAVE BOOKS IN THE BESTSELLING MY... SERIES

ISBN 13: 9780789750440 ISBN 13: 9780789751027 ISBN 13: 9780789751713 ISBN 13: 9780789751829

Full-Color, Step-by-Step Guides

The "My..." series is a visually rich, task-based series to help you get up and running with your new device and technology, and tap into some of the hidden, or less obvious, features. The organized, task-based format allows you to quickly and easily find exactly the task you want to accomplish, and then shows you how to achieve it with minimal text and plenty of visual cues.

**Visit quepublishing.com/mybooks to learn more
about the My... book series from Que.**

quepublishing.com

 quepublishing.com

Michael Grothaus

Safari ···>
Books Online

FREE
Online Edition

Your purchase of **My iPhoto**® includes access to a free online edition for 45 days through the **Safari Books Online** subscription service. Nearly every Que book is available online through **Safari Books Online**, along with thousands of books and videos from publishers such as Addison-Wesley Professional, Cisco Press, Exam Cram, IBM Press, O'Reilly Media, Prentice Hall, Sams, and VMware Press.

Safari Books Online is a digital library providing searchable, on-demand access to thousands of technology, digital media, and professional development books and videos from leading publishers. With one monthly or yearly subscription price, you get unlimited access to learning tools and information on topics including mobile app and software development, tips and tricks on using your favorite gadgets, networking, project management, graphic design, and much more.

Activate your FREE Online Edition at
informit.com/safarifree

STEP 1: Enter the coupon code: AEXYWWA.

STEP 2: New Safari users, complete the brief registration form.
Safari subscribers, just log in.

If you have difficulty registering on Safari or accessing the online edition,
please e-mail customer-service@safaribooksonline.com
